Practical
LANDSCAPE PAINTING

DOOLIN

Practical LANDSCAPE PAINTING

MATERIALS, TECHNIQUES & PROJECTS

David Hollis

Ivy Press

This edition published in the UK in 2015 by

Ivy Press

210 High Street, Lewes
East Sussex BN7 2NS, UK
www.ivypress.co.uk

First published in the UK as part of *The Landscape Painting Pack*

Copyright © 2015 The Ivy Press Limited

Text and illustrations: David Hollis

ISBN: 978-1-78240-280-0

This book was conceived, designed and produced by

Ivy Press

Creative Director PETER BRIDGEWATER
Publisher SOPHIE COLLINS
Editorial Director JASON HOOK
Design Manager SIMON GOGGIN
Senior Project Editor CAROLINE EARLE
Designer JOANNA CLINCH

Printed and bound in China

Colour origination by Ivy Press Reprographics

10 9 8 7 6 5 4 3 2 1

Distributed worldwide (except North America) by
Thames & Hudson Ltd, 181A High Holborn,
London WC1V 7QX, United Kingdom

DEDICATION
To my wife Linda for her patience about the time I spend
both with my art and at the computer screen.

CONTENTS

INTRODUCTION

WATERCOLOR IN THE PAST

From prehistory onward artists across the world have exploited water-based paints. Our ancestors used ocher pigments made from various clays to create cave paintings depicting the animals of the hunt; some of these pigments are still in use today. Water-based paints were used by most ancient civilizations, including those of the Egyptians, Romans, Chinese, and throughout the Middle Ages in Europe. Yet it was not until the 15th century that the medium began to be used in the way that we recognize today. Albrecht Dürer (1471-1528) is generally regarded as the father of modern watercolor. He worked in a wide range of media, but when traveling he favored watercolor for its portability.

Below ALBRECHT DÜRER, *"A Piece of Turf," 1503.*

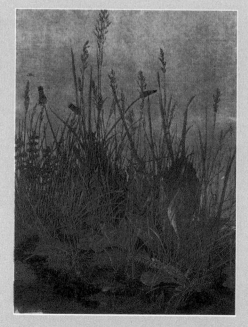

From about 1750 it became fashionable in England for the aristocratic members of society to paint in watercolor. This led to an unprecedented explosion in the use of the medium, and watercolor became associated with English artists. The link between England and watercolor lasted for over a century, with many English artists of that period contributing to the development of the medium. Thomas Girtin, J. M. W. Turner, John Constable, and notably John Sell Cotman all raised the profile of watercolor, particularly for landscape painting. The quick-drying nature of watercolor along with the subtle effects that it produced contributed to its success, and it became the medium of choice for artists accompanying expeditions. This kindling of interest in the use of watercolor by English artists of the 18th century created a similar enthusiasm in other countries.

In the United States in the latter part of the 19th century, Winslow Homer and John Singer Sargent led the way and popularized the medium still further. Today, the use of watercolor appears to increase each year, particularly among amateur artists who warm to its delicate touch and ease of application.

Artists of the 16th and 17th centuries had to grind and mix their own watercolors using pigments from plants and other sources. The pigments were ground using a glass muller with gum arabic binder, and honey as a moisturizer. By the end of the 18th century an Englishman, William Reeves, had recognized that there was a market for manufactured watercolors, which he began to sell to an eager public. A rapid development in the manufacture of watercolors took place and by 1850 Winsor and Newton in England were producing colors in tubes and packaging them in elaborate wooden boxes. Today several major brands sell watercolors around the globe in tubes, pans, and half pans. The watercolor landscapes in this book involve the use of traditional colors of the kind used by artists since the 19th century.

Above *A glass muller used for grinding pigments to produce watercolor.*

Below JOHN SELL COTMAN, *"Greta Bridge," c.1810.*

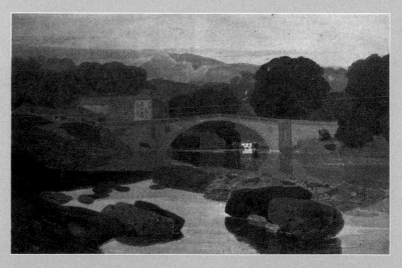

WATERCOLOR MATERIALS

To create the projects in this book, you will need brushes, paper, a palette, some absorbent tissue paper, and a selection of paints. All of the projects can be created using the seven colors opposite. The example below of a painting of Arcos de la Frontera in southern Spain shows how the suggested colors can be mixed to create a typical landscape watercolor. However, don't worry if you can't find matches for all the colors—if you are missing a color, you should be able to create something close by combining some of what you have.

French ultramarine and light red shadows in the darkness of the windows.

Prussian blue and French ultramarine sky.

Aureolin with Prussian blue and French ultramarine for distant hills.

Some areas left as the white of the paper.

French ultramarine and aureolin mixtures for the foliage.

Light red mixed with scarlet for the brighter roofs.

Yellow ocher, light red, French ultramarine, and aureolin mixtures for the rocks.

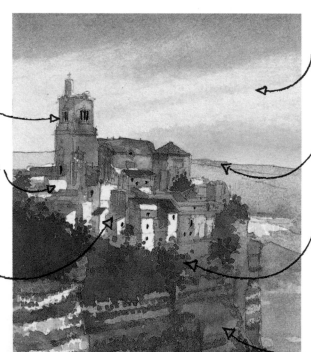

Right Arcos de la Frontera in southern Spain.

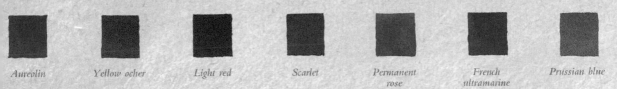

| Aureolin | Yellow ocher | Light red | Scarlet | Permanent rose | French ultramarine | Prussian blue |

You will need the colors above

BRUSHES

Nearly all watercolor techniques can be achieved with just one type of brush, the so-called round brush. The choice of brush size determines how much watercolor wash can be carried and the ease with which a point can be achieved to create the finer detail. As you work on larger sizes of paper you will tend to require larger brushes, and as the brushes get larger you will need to get brushes of the best quality to achieve a good point.

The best brushes are made from red sable and are expensive. In recent years, however, tremendous strides have been made in developing synthetic alternatives. While these may not quite match the quality of sable, they do provide a very reasonable alternative for those learning watercolor. When buying a brush, look for a wide belly to carry the volume of watercolor and a good point to deliver the detail. Round brushes range from size 000 through to size 20. Providing you can bring your brushes to a reasonable point there is little value in brushes below size 4, and you are unlikely to require a brush larger than size 12 unless you are producing very large watercolors. You may want to begin with a size 7 brush, as this will be suitable for applying washes on paper up to about 9 inches (225 mm) square.

THE ELEMENTS OF A GOOD BRUSH

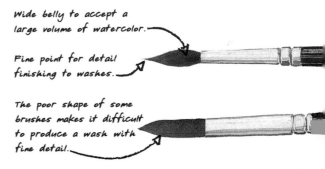

Wide belly to accept a large volume of watercolor.

Fine point for detail finishing to washes.

The poor shape of some brushes makes it difficult to produce a wash with fine detail.

9

WATERCOLOR MATERIALS

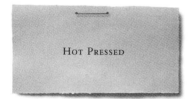

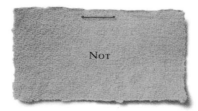

Above **Hot pressed paper is very smooth. The surface is created by the application of pressure between hot steel plates.**

Above NOT **has a medium-grain surface, which can be produced in differing ways depending on the manufacturer.**

Above ROUGH **has a surface texture exactly as its name suggests. It is more appropriate for use in large watercolors.**

PAPER

Watercolor papers are available in three different surface textures: hot pressed (HP), not pressed (NOT), and rough (ROUGH). HP is smooth and is not recommended for general watercolor work, and the ROUGH surface can sometimes be very difficult to use. For the novice user, NOT is recommended because it provides a good all-around surface somewhere between HP and ROUGH. Watercolor papers also come in a wide range of weights, measured in either pounds per ream or grams per square meter. The lightest papers are about 70 lb or 150 gsm, or twice the thickness of photocopying paper, and the heaviest, at about 300 lb or 640 gsm, are the thickness of cardboard. To follow the exercises, you will need paper that is about 160 gsm. This is suitable for smaller paintings. For larger work you will either need to stretch the paper (*see opposite*) to prevent cockling (wrinkling), or buy heavier weights of paper.

You can buy watercolor paper as individual sheets, in pads, and in blocks. While not stretched in the way described opposite, the paper in the blocks has all the edges gummed to provide some restraint to the edges, which helps prevent cockling when wet. A small area of one edge is left ungummed so that a knife can be slid under the topmost sheet to release the artwork.

> ARTIST'S TIP
> Watercolor papers are treated, or sized, to ensure that they absorb the optimum amount of color when it is applied. Each of the different brands of paper available has its own different drying characteristics, and it pays when you are first starting with watercolor to test out the various ranges of papers. Some suppliers provide samplers for this purpose.
> The best watercolor papers are acid-free to prevent deterioration of the paint with time.

STRETCHING PAPER

Watercolor paper, just like other papers, cockles when it gets wet. Although the paper tends to flatten to a degree as it dries, the cockling can make painting very difficult, particularly if you are trying to produce even areas of color. To overcome this problem you can choose from two options. The first option is to purchase much thicker paper, but this can prove expensive. The second option is to stretch the paper. This takes out the stretching that naturally occurs when you wet paper.

Above The wet paper is placed on a board and the premoistened tape is pressed down around the edges. If the tape lifts during drying, the paper can become unusable, so a thumbtack pushed into each corner is well worth the added effort.

To stretch paper, a piece of plywood or other strong board is required, which will remain flat and will not be damaged by being soaked in water. The board should provide a margin of at least 2 inches (50 mm) beyond the size of paper to be stretched. In addition to the board you also need some ordinary brown, gummed paper tape of the type that has to be wetted to activate the glue. The watercolor paper is soaked in water for a few minutes until thoroughly wet, but before it turns to pulp. The paper is then placed on the board, and precut lengths of tape are applied to the edges as shown. The tape should be premoistened and firmly pressed into place with your hand. Thumbtacks should be added to the corners to help prevent the tape tearing away when it comes under strain as the paper dries. Stretching the paper as described is particularly useful for large areas of wet-in-wet wash (*see page 14*).

LEARNING ABOUT WATERCOLOR

This book is based on a series of lessons, each of which includes a demonstration "project" for you to follow. The projects have been designed to help with a particular learning topic, and each is preceded by an outline of the topic and a description of the techniques to be used within the project. The book aims to build your skills for watercolor steadily, so that each lesson adds to knowledge and competence gained in the previous lesson. It is not as easy to correct errors made while using watercolor as it is when using oils, since corrections tend to give an "overworked" look to the final piece. You may therefore wish to try out some of the techniques required for each of the projects before embarking on the piece itself.

Project 1	Project 2	Project 3	Project 4
		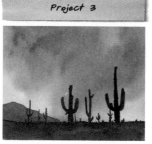	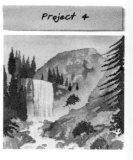

Washes form the basis of all watercolors. The first project in this book is based on the spectacular scenery of the Banff National Park in the Rockies in Canada. It uses a number of washes to create the impression of sky, mountains, lake, and trees.

This project looks at skies, an important component of landscape painting, and is based on the picturesque view of the village of Plockton on the west coast of Scotland. The aim of this project is to demonstrate how relatively simple wet-in-wet watercolor techniques can be used to create interesting and dramatic skies.

Without tonal range, paintings tend to look flat and uninteresting. The third project concentrates on the effective use of tonal contrast. Its setting is a scene from the Arizona desert, with tall saguaro cacti silhouetted against the evening sky.

The natural world is full of complex textures and patterns. This project, which is set in the Yosemite National Park, takes a look at how you can create the impression of textures and patterns in a watercolor without painting all the detail.

Right **Some sample pages taken from the project sections of the book.**

Each project begins with a description of the techniques used.

Each project page provides a step-by-step guide to completing the artwork.

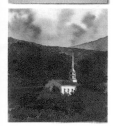

Project 5

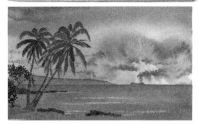

Project 6

Project 7

Sketching Trip

The fifth project takes a look at color and composition, two important elements of any watercolor. The scene is from Vermont with the white spire of the church in Stowe dramatically set against a backdrop of the fall colors.

Moving onward, the sixth project covers the creation of shapes and forms of trees, a key area in landscape painting. This project is based on the view across the bay from the Hawaiian island of Maui, with its beach palms overlooking the ocean. The project also takes the opportunity to explore a further dramatic sky set against a tranquil ocean.

The final project is aimed at helping with perspective and shadows. The project uses as a base the unusual landscape of the rose red city of Petra, Jordan, where massive structures have been carved out of the rock.

To help you put your learning into context, you are invited on a sketching trip to the west coast of Ireland, where the lessons learned in this book are put to good use in the creation of a sketchbook. Our travel journal in watercolors captures the beautiful landscapes and contrasting coastal scenery.

LESSON 1: WASHES

The term "watercolor wash" refers to laying down an area of watercolor within an artwork—the brushstrokes should not be visible, the aim being to create an even area of color. There is no equivalent in oil painting and most other art media. With oils the brushstrokes are always visible to a degree. The ability to lay down clear, crisp, even areas of color is what sets watercolor apart. There are four main types of wash.

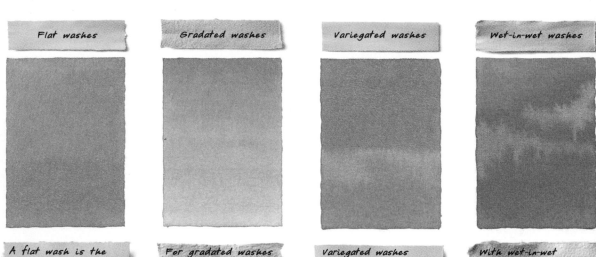

Flat washes

Gradated washes

Variegated washes

Wet-in-wet washes

A flat wash is the application of a single area of flat color. It may look simple but the fact that imperfections become clearly visible, makes it difficult to achieve a good flat wash. A flat wash may be used for a blue sky or for distant mountains.

For gradated washes the amount of water in the mix is slowly increased to reduce the color saturation. The process of adding water is known as tinting and the wash effectively becomes a continuous range of tints. It is used for skies and waterscapes.

Variegated washes involve the use of two or more colors blended on the paper. The second color is applied while the first is still wet and the two colors are allowed to mix where they join on the paper. The finished effect is useful in landscape painting.

With wet-in-wet washes, either water or a color is applied across the paper, and while this is still wet one or more colors are added. This can create a range of effects, that are particularly useful for cloudy skies, buildings, and landscape features.

A bead of watercolor is created and regularly replenished with fresh color to ensure that the bottom edge of the developing wash remains wet.

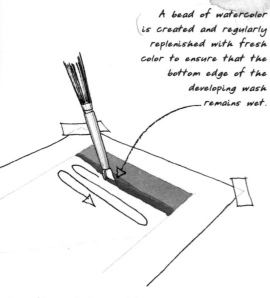

Once the wash is complete the brush is dried and used to mop up the remaining watercolor along the bottom edge of the wash.

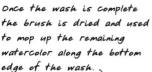

LAYING A FLAT WASH

Laying a flat wash successfully requires preparation. The corners of the watercolor paper should be taped to a piece of cardboard using a low-tack tape such as masking tape. The board with the watercolor paper should then be placed at a shallow angle as shown—this aids the flow of the wash down the paper.

The cardboard with the watercolor attached needs to be propped at a shallow angle to the horizontal.

Squeeze a quantity of French ultramarine onto the edge of your palette. Dip your brush in clean water to create a very large pool of water in the center of your palette, adding color as you go. Begin applying the color to the paper, creating a long bead of watercolor across the top of the sheet. Then use your brush to pull the bead of color down the paper. Make sure the bottom edge of wash does not dry out to avoid producing a line across the finished work. When you reach the end, dry the brush on a tissue and dip it back into the bead of color to mop it up, leaving a neat bottom edge.

GRADATED WASH

A gradated wash is produced by continuously adding water to the pool of watercolor on the palette. Start in exactly the same way as for the flat wash by creating a bead of color across the paper. Then, each time you collect more watercolor from the pool on the palette, add and mix in a couple of brushloads of water. This weakens the mix, producing a tint of the original color on the palette. As you proceed, the color in the wash will be gradated from dark to light. Finish off in the same way as for a flat wash.

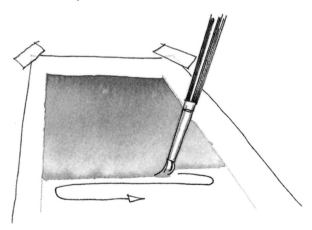

Additional water is mixed with the color in the palette each time there is a need for more watercolor to continue the wash.

VARIEGATED WASH

To create a variegated wash you will need two separate pools of watercolor on your palette. For this exercise you may like to try a variegated wash starting with French ultramarine and ending with aureolin. Start applying the wash using the French ultramarine watercolor in exactly the same way that you did for the flat wash. When the bead of color has been carried about halfway down the area of wash, rinse the brush and start with a new wash of aureolin, adding the new color to the existing bead of French ultramarine. Continue with the aureolin until you reach the bottom of the area of wash. You can then finish the wash in the same way as for a flat wash.

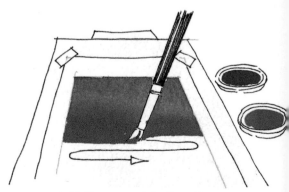

At the appropriate time the second color is introduced—the two are allowed to blend on the paper.

WET-IN-WET WASH

The approach to wet-in-wet washes is different from that used for other washes. There are two techniques: either a wash of one color is applied to the paper and another color is introduced, or a wash of clear water is applied across the paper surface and one or more colors are added. The first method is similar to applying a flat wash, the second method is somewhat different.

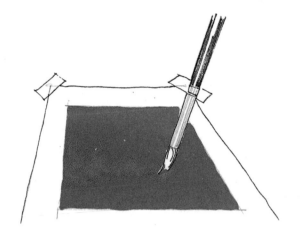

The brush is dipped in the second color and the tip is gently applied to the wet wash.

For the first method, apply a flat wash as fast as you can reasonably go, as it is important that the wash is not allowed to dry. While it is still wet, introduce the second color to the surface of the paper, allowing it to blend into the first wash. For the second method apply clean water across the entire area of the wash. Because no color is being used there is no requirement to take care in producing an even wash, but it is important to cover all of the wash area fully with water. Once the area of the wash has been soaked with water, introduce the first color from your palette onto the wet surface, allowing it to spread out in the clear water. After the first color has been introduced you can introduce other colors, allowing them to blend and mix on the paper.

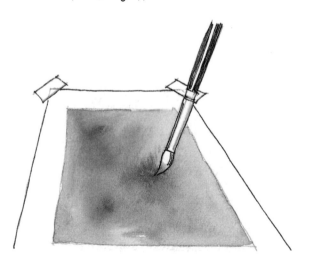

The brush loaded with watercolor is applied to the wet surface of the paper. The new color then blends with those already on the paper.

PROJECT: LAKE MORAINE, THE ROCKIES

CREATING WASHES

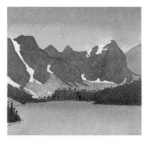

Above **The finished watercolor of Lake Moraine.**

For this project you will need a soft pencil to sketch the main features. When preparing the initial sketch it is essential to keep your pencil lines delicate because they become impossible to remove once covered with watercolor. Apart from outlining the basic shapes, be sure to provide an indication of the areas of snow; these areas will be left clear of color so they show as the white of the paper. Once the sketch is complete, lay a gradated sky wash. This should be carried down behind the mountains, making sure that no color goes over the snow areas. Running it through the horizon avoids a difficult join between the sky and mountains.

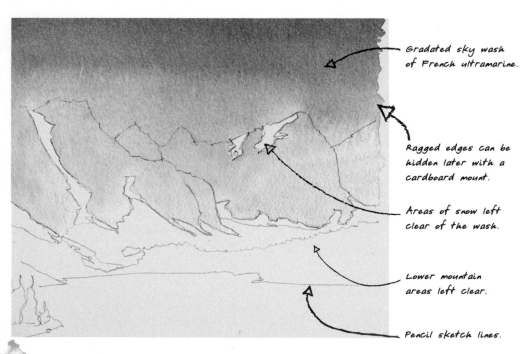

Gradated sky wash of French ultramarine.

Ragged edges can be hidden later with a cardboard mount.

Areas of snow left clear of the wash.

Lower mountain areas left clear.

Pencil sketch lines.

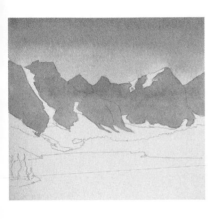

Left **The first mountain wash.**

Below **The second mountain wash.**

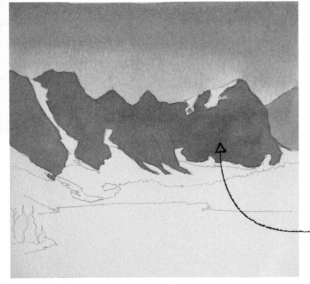

When the sky wash is dry it can be overlaid with a flat wash across the mountain areas, without initially filling the lower slopes. Once again, the areas of snow must be missed. The flat wash is a blue-gray color mixed from French ultramarine and light red.

The next mountain is closer so, to create this impression, you need to make it darker and warmer in color. You will find that by adding a second mountain wash with a little added light red you can make the necessary changes. The first mountain wash must be dry before the second mountain wash is applied across the middle distance and closest mountain. While the wash is still wet, light red color can be randomly added using the wet-in-wet technique. This makes the wash more interesting visually.

Light red is added into the warm gray using the wet-in-wet technique.

FACT SHEET
The Rockies are a vast mountainous region running from Colorado in the south to Alaska in the north. They attract millions of visitors each year. Lake Moraine is about one hour west of Banff in the Canadian Rockies and close to Lake Louise. The mountains of the Ten Peaks Valley form a backdrop to this lake.

LAKE MORAINE, THE ROCKIES

For the next wash you will need some medium-grain household salt. The salt is applied once the wash has been laid. It absorbs some of the water, creating rocklike patterns in the finished work. Begin by mixing a similar wash to that used for the previous mountain, but this time add some permanent rose to give it a violet-gray color. Apply the wash across the closest mountain, varying the amount of permanent rose in the mix, to create a variegated wash. You will also need to continue the wash across the previously untouched area of the lower slopes, which are composed of relatively fine, loose rock. While the wash is still wet, sprinkle the salt in the lower mountain area. The wash will take longer to dry than normal. When it is completely dry scrape the salt off, leaving the patterned wash. Once all the washes are dry, and to give some indication of shadows in the folds of the middle mountain, use some of the violet-gray wash to add shadow areas.

> **ARTIST'S TIP**
> Salt can be used in a wide variety of situations where you want to give the appearance of detail without painting any yourself.

Salt is applied across the lower slopes to imitate loose rock. Some will inevitably spill over onto the other parts of the wet wash but that helps to add texture to the closest mountain. Once completely dry the salt is rubbed off the painting with the edge of a piece of thin cardboard.

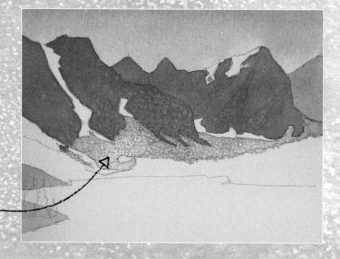

Below **The lake wash.**

The lake is added next as it needs to sit behind the lower edge of the tree belt, which is added last. A colored wash of Prussian blue and aureolin is mixed on the palette to produce the beautiful turquoise color of the lake. This is applied as a gradated wash.

The color can be quite strong near the shoreline to give a hint of the reflection of the trees. To achieve this, start with a colorful wash and then add plenty of water. The wash should rapidly gradate to a much lighter wash in the foreground.

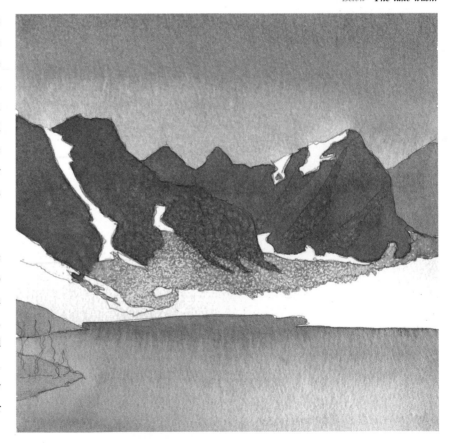

LAKE MORAINE, THE ROCKIES

The trees are added last of all. They consist of a variegated wash of muted greens. The green is made with French ultramarine and aureolin. This wash needs to be applied from left to right (or right to left), with the proportions of the mix varied throughout the wash to create a variegated wash with a range of muted greens. With trees and foliage it is important that the wash does not look too heavy and dense. This can be achieved by making sure that the top edges of the trees have a very broken appearance, as shown below.

Once this is dry, the foreground trees on the left can be added, and an impression is provided of some of the trees at the front of the main area of trees. These last details are important as they help provide scale to the painting by giving a clear impression of the massive size of the mountains behind. If you want to display your watercolor, the ragged edges of the watercolor can be covered by a cardboard mount.

Use a variegated wash for the trees. Once this wash is dry, additional detail can be added to give an indication of individual trees.

Above **Developing the tree belt.**

Right **Final watercolor of Lake Moraine.**

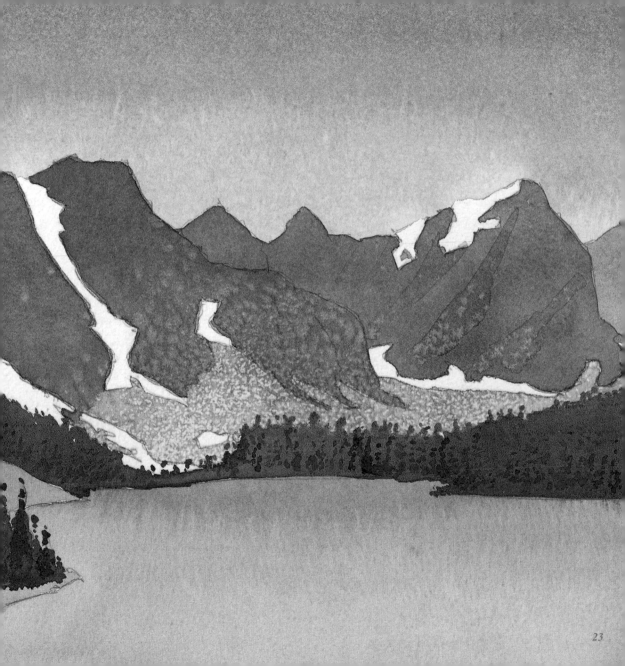

23

LESSON 2: SKIES

CLOUDY SKIES

For this lesson we look at using wet-in-wet techniques to create cloudy skies. The key to producing convincing skies lies in an ability to form the fine detail of the wisps of cloud as it blends into the blue of the sky. By using a wet-in-wet wash it is possible to achieve this with very little effort. When painting the blue of skies in the temperate areas of the globe, it is best to mix the wash using French ultramarine alone. For painting skies in subtropical areas, use French ultramarine mixed with Prussian blue to produce an accurate color. The area of the sky needs to be thoroughly wetted. The blue of the sky is then introduced to about one-third of the area in a random way. The paint spreads into the wetted surface producing cloudlike fronds as shown. The clouds are the untouched areas of white paper.

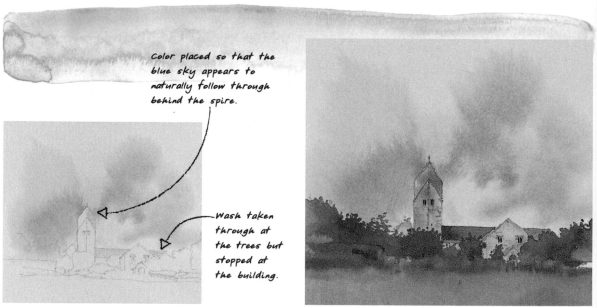

Color placed so that the blue sky appears to naturally follow through behind the spire.

Wash taken through at the trees but stopped at the building.

Above **Creating a cloudy sky over Sompting Church in Sussex, England.**

Above **The completed watercolor.**

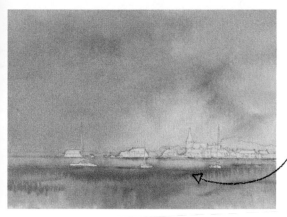

In this example, the wet-in-wet sky wash was taken across the entire page with the exception of the buildings and the boats. Yellow ocher and French ultramarine mixed with aureolin was then used to create the mud flats in the foreground.

Left Creating a dark and brooding sky.

Below **The completed watercolor of the harbor in Bosham, in Sussex, England.**

This technique can be extended to produce dark, menacing skies. Three wash mixtures are required: a French ultramarine wash, a light red wash, and one that mixes the two colors to make gray. The sky area is wetted and the French ultramarine and gray washes are applied in a random way. Small patches of the light red wash are then introduced and the brush is used to help mix them on the paper. The colors tend to granulate, producing texture within the color. This is caused by the pigment settling into the shallow hollows in the paper. The texturing helps give the impression of heavy clouds.

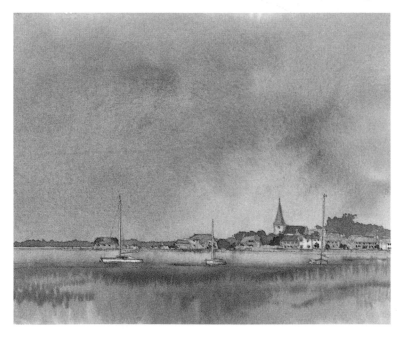

BLUE SKIES

Although the project featured in this lesson uses wet-in-wet to depict a wild and dark sky, it is often necessary to depict blue skies. When you look at blue sky in real life you find that there is a natural gradation in the sky. In moving your eye toward the horizon, the relatively deep blue of the sky tends to become lighter in color. As an artist you need to reflect this in your approach—this was the reason why a gradated wash was suggested for the Lake Moraine project.

Below A gradated blue sky in Tuscany, Italy.

If you stop a sky wash at the horizon it becomes too easy to create small areas of white between the washes for the sky and the land or sea. You will find that small areas of white like this detract from the finished picture. Using a gradated wash, which is relatively light at the horizon, allows you to take the sky wash through the horizon and then overlay it with washes for the land or sea. This avoids a "join" between the washes.

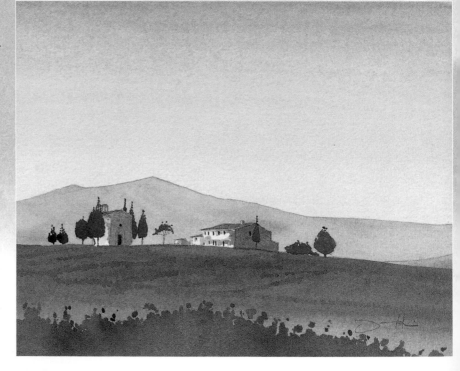

MORNING AND EVENING SKIES

Effective morning and evening skies can be created by using variegated wash techniques based on two colors blended while they are wet. In the example shown the wash was based on a muted yellow mixture of aureolin and yellow ocher at the top and a violet-gray mixture of French ultramarine, permanent rose, and light red at the bottom. The sky wash was taken through the horizon, and the sun, which is the brightest object within the painting, was left as the white of the paper, although a little of the violet-gray wash was touched into the sun area to create the impression of clouds passing in front. After the sky wash had completely dried, the area of the sun was rewetted and some of the color was "lifted out" using a tissue as blotting paper. This softened the cloud in front of the sun. It was repeated several times, with care being taken only to wet the area of the sun. Similar methods can be used for both morning and evening skies.

Below **The Madonna di San Biagio in Tuscany, Italy.**

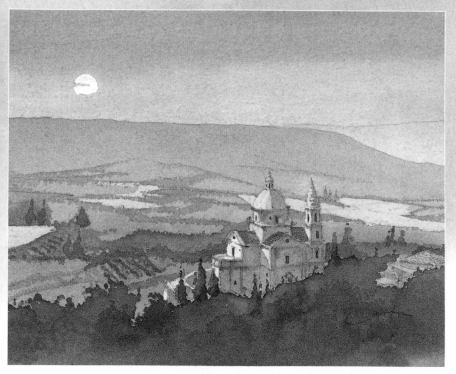

27

PROJECT: THE WEST COAST OF SCOTLAND

CREATING A BROODING SKY

To begin this project, prepare an outline of the main elements in pencil, using the finished watercolor on page 31 as the basis. Where there is a clear horizon with the sea, it is always important to ensure that it is straight and level and, although the use of a straight edge is not generally recommended, this is one instance where it can be useful. The details of the village houses need only to be suggested. Once the sketch is in place the sky wash can be applied using wet-in-wet techniques. The aim is to create an impression of the dramatic skies that can occur when heavy and thundery clouds are moving across the sky. The sun frequently becomes hidden behind the clouds, creating bright areas of sky, which can then take on an incandescent yellow appearance.

> **ARTIST'S TIP**
> Washes always dry lighter than you would expect. It will take time to learn just how dark to make a wash to achieve the right effect. Keep scraps of watercolor paper handy to test washes.

The first task is to wet the area of the sky and mountains, leaving clear the buildings and boat masts. The washes are made of varying mixes of French ultramarine and light red for the gray clouds, and mixtures of aureolin with a little yellow ocher for the background sky. These should be applied to the wetted areas of the paper and the color allowed to bleed across the surface. The central area of yellow should be applied first and then the clouds. The area near the horizon should be left as light as possible for dramatic effect. If the color moves in unexpected ways, some control can be applied by tilting the paper at varying angles.

Right **Thundery skies across Plockton—the pencil sketch with the finished sky wash.**

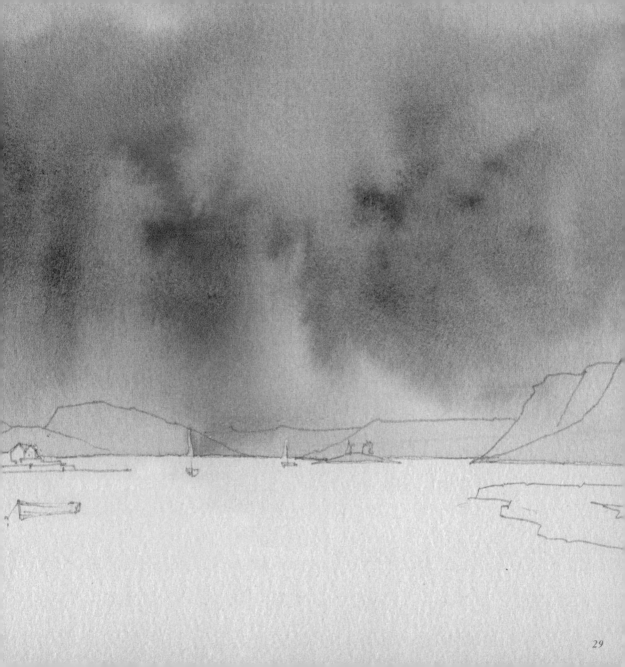

THE WEST COAST OF SCOTLAND

Once the sky wash is dry, washes can be applied to the mountains. To create an illusion of distance, the furthest mountain should be the bluest and the lightest in color. An initial blue-gray wash mixed with French ultramarine and light red should be used to cover all the mountain areas. When dry, further washes with more light red can be applied over the middle distance and closer mountains. Finally, variegated washes of varying amounts of the violet-gray color mixed with a little aureolin should be applied to the closest mountain areas and the island. The buildings and boats are left clear of color at this stage so that they contrast with the dark tones of the mountains.

The sea is probably the most difficult part of the watercolor. The intensity of the glare from its surface demands that the sea near the horizon is left totally white, creating the stark contrast with the mountains. A wet-in-wet wash is used, with color kept clear of the far distance. The principal color is aureolin, with watered-down versions of the washes used for the sky added to the foreground. The edge of a folded tissue is placed on the wet surface of the sea wash to lift out some of the color and produce white lines across the wash. These are to imitate waves in the foreground. Aureolin mixed with yellow ocher is then used to create thin straight lines across the foreground to reinforce the appearance

Below West coast of Scotland—the initial mountain wash.

Below West coast of Scotland—the completed mountain wash.

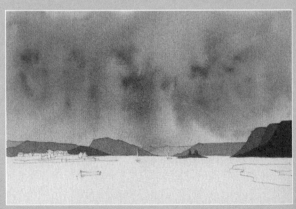

Below **West coast of Scotland—the sea.**

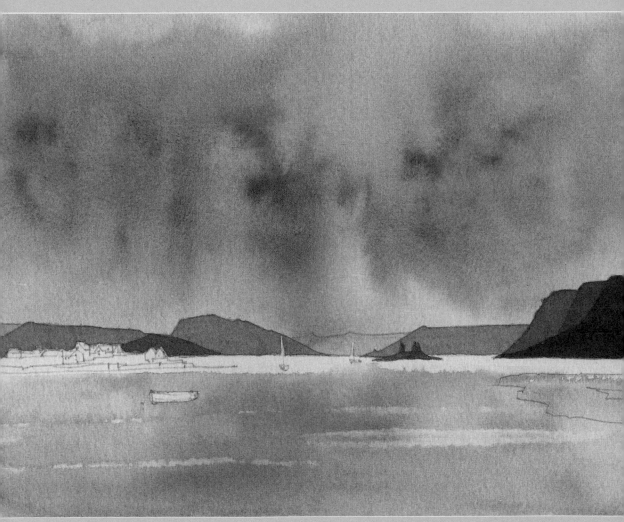

THE WEST COAST OF SCOTLAND

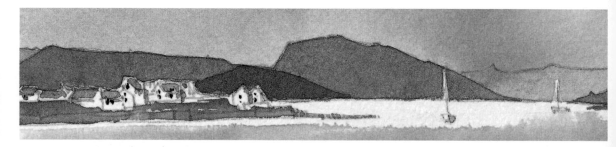

Above **The village detail.**

The key elements of the watercolor are now in place but it still has an unfinished look. The foreground rocks and the detail of the village need to be added. The gray roofs are painted with a French ultramarine and light red wash, which has a little aureolin added. Shadow is also provided using a French ultramarine and light red wash, and the dark windows of the houses are created with an almost black mixture of the strongest possible mix of these two colors. Much of the cottages should remain white to create the contrast with the mountains. Strictly speaking, the faces of the walls that can be seen should all be in shadow, but that would not produce the dramatic effect of contrasting the village against the dark colors of the mountains. The green and yellow ocher of the land around the houses should also be added and some shadow applied to the boats.

The foreground rocks should now be added and then the waves improved to complete the watercolor. The white areas of the small waves can be extended by scratching the surface of the watercolor with a sharp knife. This produces the feathered edges typical of waves. The method can also be used effectively around the base of the foreground rocks and the rowboat in the middle distance.

Right **Scratching the surface to extend the white areas.**

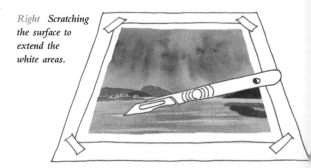

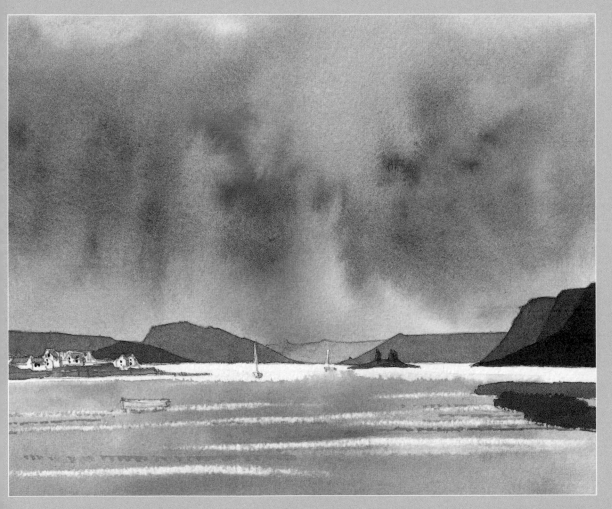

Above **The completed watercolor of Plockton.**

LESSON 3: TONAL RANGE

There is a range of grays or tonal values between black and white. When a black-and-white copy of a colored photograph is made, the colors are reduced to a range of these neutral tones from black through to white. Some colors, such as yellow, only have a limited potential for tonal range as the color is relatively light even when at maximum saturation. Other colors, such as blue, have the potential for a very wide tonal range. Generally watercolor paintings, like all artworks, benefit from having a wide tonal range. The quick sketch of a tower in rural France shown here was undertaken on location some years ago. When the sketch is placed in a black-and-white copier, the limited range of tonal values becomes clearly evident, with most of the colored areas becoming the same mid-gray.

Tower sketched on location in the Loire Valley, France.

A grayscale version of the sketch.

The sketch was updated to produce a greater range of tonal variation and this produced a far more powerful image. In this second version the colors remain similar but the tonal range and tonal contrasts have been extensively changed, reflecting the strong contrasts created on a bright summer's day.

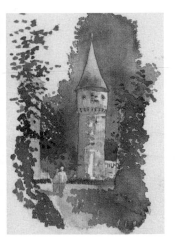

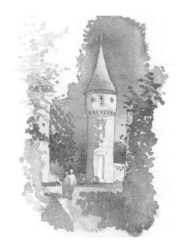

Updated version of the sketch with enhanced tonal range and contrasts.

A grayscale version of the updated sketch.

roof a little diffuse shading was added. Additional darker trees were added to the forest behind the tower to provide some differentiation of tonal values within the foliage and to create dark tones, to contrast with the tower. The people now stand clear of their surroundings because of the tonal contrast with the background and a specific, dedicated shadow. In the foreground the lighter tree on the left was allowed to overlap the darker background, providing contrast with the light tones sitting on top of the dark background. Within the openings of the tower a very dark mixture of French ultramarine and light red was used to depict the deep shadow of the space within. Using the widest possible range of tonal values and juxtaposing dark and light areas helps to define form.

In the second version, the sky was again left white to maximize the contrast with the trees. Where an area of sky is small you tend not to notice its precise color and so white can be used. The roof of the tower was left as light as possible to contrast with the trees behind, and to give some sense of the curved shape of the

CREATING A WATERCOLOR IN JUST ONE COLOR

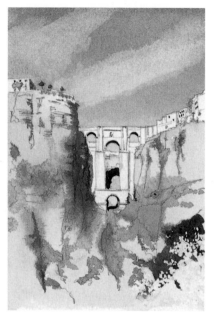

Above A watercolor of the gorge at Ronda, Spain, based on the use of one color mixed from French ultramarine and light red.

One method of establishing a good range of tonal values in a watercolor is to develop an initial draft using one color—a monochrome painting. This forces you to use tonal rather than color variation to establish the various forms in the painting. In the example shown, a range of grays was produced, with the darkest being close to black and the lightest the white of the paper. The grays were mixed from French ultramarine and light red, keeping the same ratio of color mixture while varying the amount of water in the wash to create the range of tints. Establishing the range of potential tonal values like this helps with the next stage of producing the finished watercolor. The subject chosen is Ronda in Andalusia. The view is from below the cliffs on which the town stands.

A monochrome painting can be of interest in itself and some artists like to work in this way. Not all monochrome paintings have to be based on a gray color. If you wanted to give the scene a warmer feel you could increase the amount of light red, and possibly add a touch of aureolin, to create a sepia color. This would provide the warmth we tend to associate with old sepia photographs.

Below Range of tonal values using a mix of French ultramarine and light red.

TONAL VALUES AT WORK

The illustrations on this page show the way tone can be used to good effect. In the picture below the fence posts initially pass in front of the dovecote, which is light, and then in front of the forest, which is dark. To achieve the right contrast with both backgrounds, the color of the posts is varied from almost white through to a darker gray. The eye does not notice this variation but it does recognize the clear contrasts.

Below Dovecote at Château Saint-Gervais in Normandy, France.

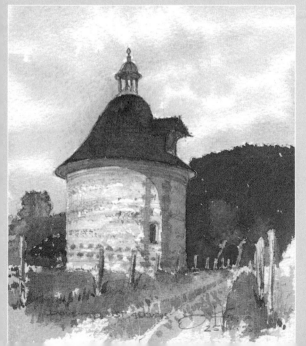

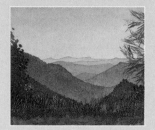

Above View from Col Saint-Pierre in the Cevennes in southern France.

In the painting above, the great distance of the farthest mountains is highlighted by the use of ever lighter and bluer tones, a technique known as aerial perspective.

BLACK

No black has been included in these exercises. This is because there is a problem with using ready-made blacks as they tend to create stark contrasts that can detract from the subtle qualities associated with watercolor. Mixed blacks will inevitably vary in color and tone producing a more natural feel, and it is these subtle variations that take away the starkness of true black and give the painting a more natural feel. For most purposes you will find that a simple mix of French ultramarine and light red with the minimum amount of water will deliver a color that is close enough to black. Should you want to create a color that approximates still closer you will need to add some yellow ocher or aureolin.

PROJECT: **ARIZONA DESERT**

USING TONAL CONTRAST

Some of the simplest watercolors can be the best. This next project is based on a very simple approach. Just four washes are required to complete the finished work. The impact comes from tonal contrast. Once again, you need to start by doing a pencil sketch, following the example shown on page 39. Accuracy in reproducing the scene is not critical, and you should not make the saguaro cacti look too perfect, otherwise the effect might be to make the painting too cartoonlike. Real cacti suffer the ravages of time and consequently they tend to look somewhat ragged and misshapen around the edges.

Above **The completed watercolor.**

The first wash uses wet-in-wet techniques. Here the entire area is wetted before the colors are introduced into the wet surface. A series of premixed washes is needed to bleed into the wetted surface: orange reds, reds, and violets in the sky, and yellow for the desert floor. The base color for most of these is permanent rose mixed with aureolin for the orange reds and reds, and with French ultramarine for the violets. For the desert floor, a color mix based on aureolin and yellow ocher is used. The washes should be applied to the wetted paper creating an abstract color arrangement that will eventually become the sky and desert floor.

FACT SHEET

The state of Arizona covers almost 114,000 square miles (295,000 sq km). The Sonoran Desert, the home of the tall saguaro cactus, covers the entire southwestern corner of the state and extends into neighboring California and Mexico. This is the hottest of the North American deserts but there are two rainy seasons, which allow a wide diversity of plants and animals to survive.

Below **The Sonoran Desert;**
the initial sketch with the wet-
in-wet sky and background wash.

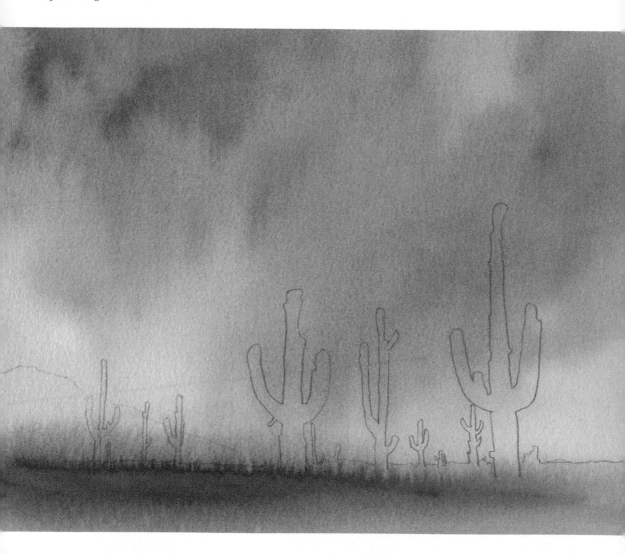

ARIZONA DESERT

Once the first wet-in-wet wash is completely dry the background hill can be added using a flat wash mixed from French ultramarine and permanent rose. At this stage the bulk of the watercolor is in place. All that remains to be added are the very dark areas of the cacti, scrub, and the ground surface. Although in theory it should be possible to apply the color for these areas all at once this does not necessarily lead to the best results. To achieve the

very dark color only a limited amount of water can be added and this makes the wash difficult to apply. Two sequential washes should therefore be applied to the dark areas, allowing the first to dry fully before applying the second. The washes should be made from French ultramarine mixed with permanent rose and light red to produce a muted deep violet color. For both washes the areas of the ground should be fully wetted with clear water before applying the wash to the cacti. If the cardboard with the paper is tilted at an angle, the wash from the cacti will run down into the wetted area, producing dark coloration without fully covering all of the yellow. Some of the violet wash should also be applied to the lower edge of the artwork and the paper tilted the other way to allow it to flow upward. Approaching the desert ground in this way avoids it becoming one solid dark mass, hinting at some of the evening light reflecting from its surface.

Left **The background hill wash.**

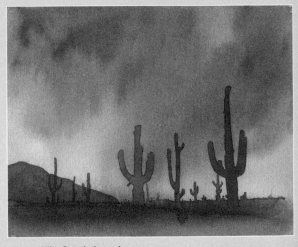

Above **The first dark wash.**

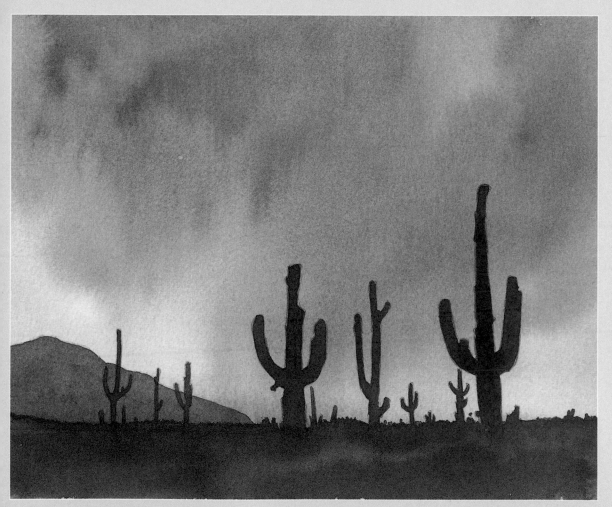

Above **The completed watercolor of cacti in the Sonoran Desert.**

LESSON 4: TEXTURE AND PATTERN
DISCOVERING PATTERN

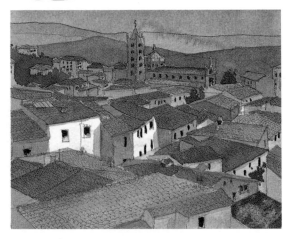

Above **Pattern in the roofscape of Massa Marittima in Tuscany, Italy.**

Below **Pattern in agriculture among the lavender fields of Provence, France.**

Patterns made by both man and nature can be very useful in creating art. Pattern provides an anchor for the viewer and provides a useful basis of composition as it allows the viewer to roam across the painting without necessarily seeking a focal point.

The curved Roman tiles of the Mediterranean region create interesting patterns in themselves and it is possible to produce watercolors concentrating purely on the pattern of the tiles, particularly when they are old and weathered. As you step away from the buildings another pattern emerges. Many Mediterranean villages cling to hillsides, affording a view across the village roofscape. An organic, almost abstract pattern emerges from the myriad roofs that are clustered together.

Farming inevitably creates pattern in the landscape; the regular and relatively straight lines created by the plow and the seed drill are one such example, and these have been exploited by many photographers and artists over the years. In the example shown on the left, the pattern created by the lavender fields draws the eye into the picture. Similar patterns can be found in other crops, and in patchworks of small farms viewed from a high vantage point.

Some patterns are not directly manmade. The repeating form of bright yellow sunflower heads is a feature of many fields across France, and the image is so iconic that it immediately evokes a feeling of traveling through the French countryside. Pattern often highlights our location. The pattern formed by the lines of cypress trees is also easily recognizable as Mediterranean, especially when the curving brushstrokes so favored by Van Gogh are used.

Right **Pattern in the sunflower fields of France.**

Granulation in watercolor.

Adding salt to a wash to produce a textured finish.

Using bubble wrap to add texture.

RESOLVING TEXTURE

A scene of rocks is filled with the minute detail of crevices, lichen growth, and variations in surface color. An artist cannot realistically reproduce all that detail, but can provide an impression of it. The trick is to harness the natural effects of watercolor. Granulation in watercolor creates a patterned appearance, which can be used to emulate the textures found in distant trees and rocks. Spreading salt across a wet wash produces a far more pronounced texture, which can be particularly useful for depicting small loose rocks in the foreground or middle distance. Other, more distinctive, textured finishes can be created by pressing embossed paper towels or bubble wrap into the wet watercolor.

Most of the techniques used to create texture rely for some of the effect on being used with variegated washes, so that there is a combination of texturing with color variation. The result that emerges then becomes reminiscent of naturally weathered materials.

LEAVING WHITE

Although it is possible to purchase white watercolor paint, it is opaque and the effect of using it tends to detract from the very qualities of watercolor that so many admire. The preferred approach is to leave the white of the paper. This can be achieved in a number of ways. For large areas you can simply leave the area without paint, and this method is used along with others in this project. However, sometimes you just want to leave hints of white, and for this you need to use different methods.

The first option is to apply a wash and then, before the wash has dried, use a folded absorbent tissue to "lift out" some of the color that has been applied. In this example it has been used to create the impression of the natural faceting of the mountain, although it can be used in many other ways, including in the creation of cloud in skies.

Dry tissue and sponge applied while the wash is still wet.

Right Lifting out using a combination of a sponge and absorbent tissue paper.

The technique can be extended with the help of a damp sponge, which can be used to soften the edges of the area of white. It is particularly useful in depicting the edge of foaming water. Here, the large area of white was initially lifted out using a tissue, and the edges were then softened using an artist's sponge, which can be purchased from any watercolor supplier.

Right Lifting out using a folded absorbent tissue.

Another method for leaving white involves the use of resists. To create the texture on the old wooden gate shown on the right, white candle wax from an ordinary candle was pulled across the paper on some of the area of the gate and stones. As the paint is applied the wax sheds the water, creating a textured effect that tends to mimic old and weathered materials.

Above **Using a candle to act as a resist.**

Below **Creating white with masking fluid and scratching out.**

Masking fluid is a thin rubber solution; when applied with a brush to watercolor paper it resists the watercolor. Once the washes are dry the rubber solution is rubbed away with the finger leaving white paper. However, it tends to create rather hard edges, which are not suitable for some subjects. To overcome this problem, a sharp knife can be used once the masking fluid had been removed to feather the edges by scratching away some of the paint. Resists can also be used over an existing wash. After a further wash has been applied and allowed to dry the masking fluid can be removed, leaving the color of the preceding wash in place of the masking fluid. Using combinations of these methods with variegated washes allows you to build complex textures relatively easily.

> **ARTIST'S TIPS**
> Masking fluid tends to set on the brush used to apply it so it pays to keep a cheap brush especially for use with the fluid. Wash it out with soap straight after use. A mapping-style pen nib can also be used to apply lines of masking fluid.

PROJECT: VERNAL FALLS, YOSEMITE NATIONAL PARK

CREATING TEXTURE AND PATTERN

How do you turn a scene into a piece of art? It is entirely possible to create highly detailed pieces of art, which can get close to the appearance of a photograph. But then, why not use a camera, and is it really art if all you are doing is reproducing what you see?

Before the invention of the camera the work of some artists, such as those traveling with expeditions, involved the precise recording of the scenes that lay before them. Today, however, art needs to go beyond mere reproduction and look for ways to evoke emotion in the mind of the viewer. Attempting to simply reproduce all the minute detail of a scene such as that at Vernal Falls may produce an accurate picture, but such art frequently looks "dead." It lacks the power and grandeur experienced by those who actually visit the place. The aim is to produce a work of art that evokes emotion, the emotion you would expect to feel when experiencing the foaming and raging waters of the fall set against the tranquility of rocks and the trees of the area. Watercolor comes to life when the artist exploits the natural qualities of the medium to the full.

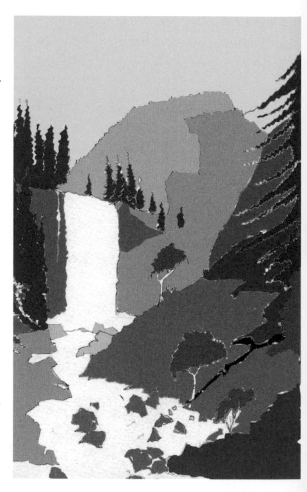

Above *A stylized outline of the Vernal Falls with the components identified in color.*

To create the watercolor, you need to first break down the scene into its simplest components and then rebuild the whole using the natural effects of watercolor to evoke the feeling of movement, of cascading spray, and of the textures and patterns of the landscape. To help you prepare your initial pencil sketch, a basic outline of the scene with flat color added to identify the main elements is provided. The basic sketch that you need to prepare sits on this page for comparison. You do not need to be completely accurate when transferring the sketch, as those who view your art will not know exactly the form of the rocks at Vernal Falls. Indeed, if you compare my sketch with the real-life scene you will find that I have considerably simplified the scene.

FACT SHEET

Yosemite National Park is an area of 1,170 sq miles (3,030 sq km) in the state of California. The area is home to the giant sequoia tree, the world's largest living thing. The Vernal Falls are 317 ft (97 m) high and are so called because the spray from the falls creates a lush green canyon that has a springtime appearance throughout the year.

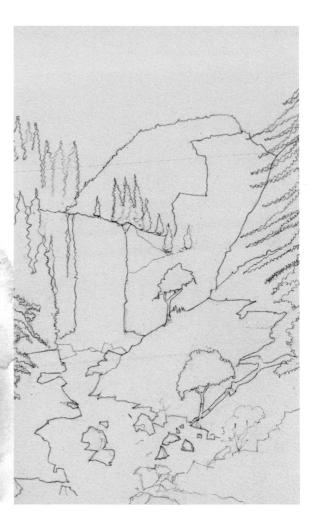

Above **The initial pencil sketch.**

VERNAL FALLS, YOSEMITE NATIONAL PARK

A simple sky is added first, consisting of a gradated wash of French ultramarine. After the first area of this wash has been started, clean water is introduced to the bead of color to produce the rapid gradation to a much lighter wash, hinting at the existence of low-lying cloud. The wash is taken through the background mountain to the line of the middle-ground rock. The bottom edge of the wash is "lifted out" with absorbent tissue to produce the effect of spray from the falls. You can use a sponge or dampened tissues to soften the edge.

Area "lifted out" with absorbent tissue and sponge.

Left **The sky wash.**

Areas with wax resist show through the blue of the original sky wash.

Above **The first mountain wash.**

Once dry, a candle should be pulled across the mountain and rock areas to create parts that will resist the washes to follow. After this is done the first variegated mountain wash can be applied using French ultramarine mixed with light red to produce the blue-gray, and with aureolin added to produce the muted green. Once again, the area of the water spray should be lifted out. The nearside face of the mountain is added next using a variegated wash based on various mixtures of French ultramarine and light red. Once the wash is in place on the left-hand side of the falls, the form of the cascading water begins to appear.

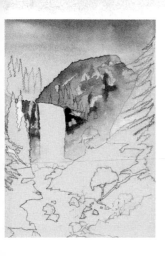

Right **The foreground wash.**

Left **The second mountain wash.**

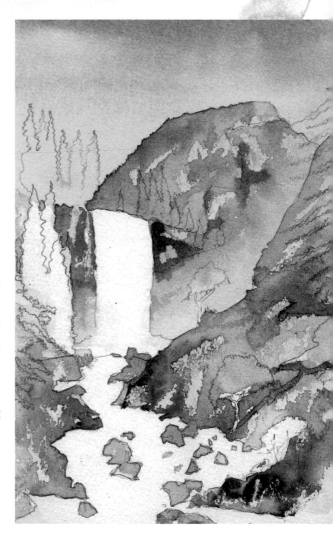

The final variegated wash goes over the foreground rocks. The colors forming the variegated wash continue to be based on mixtures of French ultramarine, light red, and aureolin, with the very red areas of rock in the foreground based on a mixture of French ultramarine, permanent rose, and light red. Additional color can be added to the rocks as the paint is drying to produce soft-edged shadow. Where candle wax has been added, the white of the paper once again shows through as highlighted rocklike textures. Getting the right amount of candle wax is not easy and it is a good idea to practice first.

VERNAL FALLS, YOSEMITE NATIONAL PARK

There are two further elements required to finish the watercolor: the addition of the trees and foliage and the finishing touches to the white water. Although generally you should work from back to front in a watercolor where there are light trees in front of dark trees, it sometimes pays to work the other way around. The usual mixture of French ultramarine and aureolin can be adjusted to lean toward the yellow so as to produce the light yellow-green of the foreground trees. Almost neat French ultramarine can be added while the wash is still wet to produce the sharply contrasting shadows within those trees.

Once these washes are dry, further washes can be added to create the background trees, where necessary working around the edge of the foreground tree wash. The repeating pattern of background pines is created with a blue-green mixture based once again on French ultramarine and aureolin. At this time, shadow can also be added to the trunks of the middle-distance trees. To complete, the foliage color needs to be applied to create the detail of the pine on the right-hand side. This has light red added to the previous wash to give a reddish tinge.

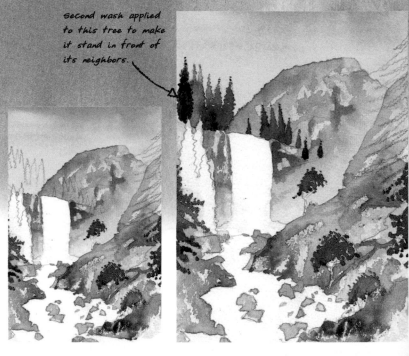

Second wash applied to this tree to make it stand in front of its neighbors.

Above **The foreground trees.**

Above **The repeated pattern of the pine trees.**

Final touches are required to improve the form of the water. A light-gray wash of French ultramarine mixed with light red can now be used to create the shadows in the falling water. A sharp knife comes into play to scratch away some of the hard edges of the foreground water, so that the line where the water meets rocks can be softened. The same knife should also be used to scratch the surface to give the impression of the tiny droplets of water, thrown up and contrasted against the rocks of the river bank. Once all this is complete the finished picture emerges.

Right **The finished watercolor.**

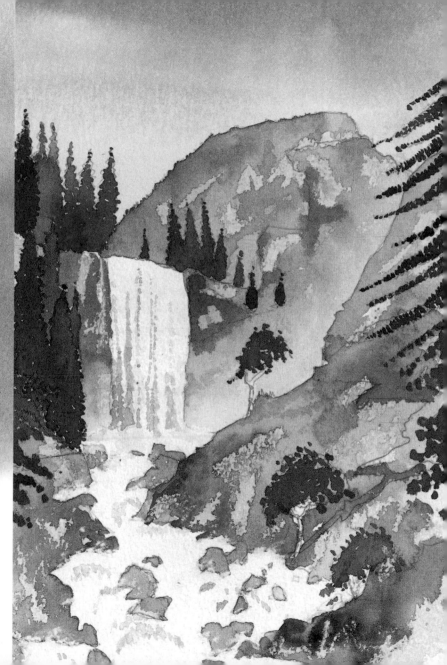

LESSON 5: COLOR AND COMPOSITION

COLOR MIXING

The primary colors are those from which artists can make all other colors. Although red, yellow, and blue have traditionally been regarded as the primary colors, this is not accurate. The true primary colors for artists and printers alike are cyan, magenta, and yellow. You may have encountered them if you use a computer for graphics-based applications, which sometimes refer to CMYK (cyan, magenta, yellow, and black) for the primary colors of the printing inks and to RGB (red, green, and blue), which are the primary colors of the screen and the secondary colors for paint and printing. The reason for the difference is that computer screens emit light, while paintings and print materials reflect light. Black is added by printers for reasons of economy.

A color circle, shown here using the colors from the pack, helps to clarify how colors relate. The added notes describe how the colors are derived. There are three terms in common use with regard to color: the hue, saturation, and value. The hue is a color's quality, which enables you to describe it as, say, red or blue. Saturation is the amount of hue in a particular color, and value is the relative darkness or lightness of the color.

THE COLOR WHEEL

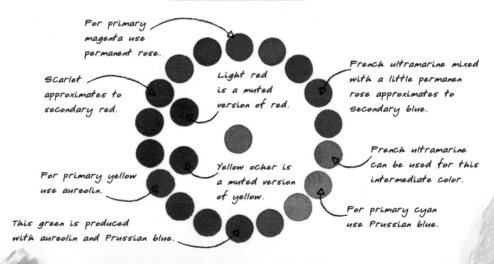

For primary magenta use permanent rose.

Scarlet approximates to secondary red.

Light red is a muted version of red.

French ultramarine mixed with a little permanent rose approximates to secondary blue.

French ultramarine can be used for this intermediate color.

Yellow ocher is a muted version of yellow.

For primary yellow use aureolin.

For primary cyan use Prussian blue.

This green is produced with aureolin and Prussian blue.

COLOR HARMONY

Certain colors appear to work well together while others clash. The color wheel can help to determine the ranges of colors that are likely to work well together. This is known as color harmony, of which there are six types. The following pages demonstrate the practical use of some of the color harmonies, while the illustrations below outline these color harmonies.

1. MONOCHROMATIC
Monochromatic harmony is where one color is used with a range of neutral colors consisting of black, white, and grays. You can also include grayed-down or muted versions of the color.

2. ANALOGOUS
Analogous colors lie close together on the color wheel. If these are used together with their muted versions and a range of neutral colors, harmony will be achieved.

3. COMPLEMENTARY
Complementary colors lie opposite each other on the wheel. Once again you can use the colors with grays and the muted versions. Mixing the two colors should create the range of colors between the two and with approximately 50 percent of each a neutral gray.

4. SPLIT COMPLEMENTARY
This is a useful variation on the complementary. It is equivalent to analogous color harmony with the added complementary color and its muted variants.

5. DOUBLE COMPLEMENTARY
As the name suggests this is two groups of analogous colors lying opposite each other on the color circle.

6. TRIAD
The triad color harmony is based on three colors that are equidistant from each other on the color wheel. This color harmony is less useful but is included for consistency.

COLOR HARMONY

Examples of the use of color harmony are shown on these two pages. You will recognize the Arizona scene from an earlier project, with the next two watercolors based on the scene of the covered bridge in Albany during the fall and winter. The final subject is the view of Florence from across the Arno River.

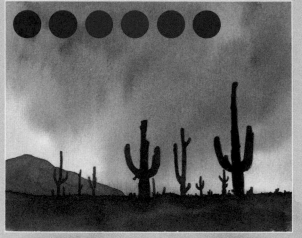

Above **The Arizona Desert—analogous color harmony.**

The colors of the scene in the Arizona desert have been adapted to make them analogous. Although the scene represents a real landscape, the use of colors that matched those in real life would lead to a less satisfying piece of art. As discussed previously, in art you are not trying to record an exact copy of what you see. If you simply require a record of a scene a camera offers a far better solution. With art you are attempting to elicit emotions in the viewer through subtle but important adaptations of the scene.

The more narrow the range of colors used, the more harmonious will be the color range. Our watercolor of Arizona uses a range of hues from red through to violet, all of which naturally sit well together. The other examples also create color harmony by restricting the range of colors in use. The Albany Bridge in the fall is based on a split complementary color harmony, although the complementary color of the blue of the sky has been muted to a blue gray so as to emphasize the colors of the fall and make them look even brighter. This reinforces the main message of the artwork, which aims to evoke in the viewer some of the emotions that you experience when you see the bright and beautiful colors of the fall.

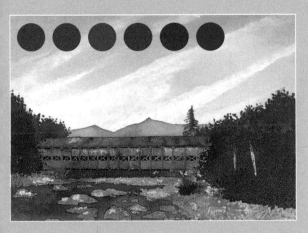

Above **The Albany Covered Bridge in the fall—split complementary color harmony.**

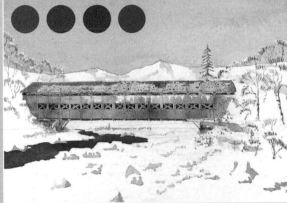

Above **The Albany Covered Bridge in winter—split complementary color harmony.**

Using just two balanced complementary colors produces a high degree of contrast. The aim of the sketch of Florence was to evoke in the viewer something of the clarity with which you see the city from the far bank of the river. The complementary color scheme helps deliver that clarity and sharpness of contrast between the city and the hills behind. In this example the two colors were based on Prussian blue for the background and scarlet mixed with light red for the foreground. The walls of the buildings are based on a tint of this red.

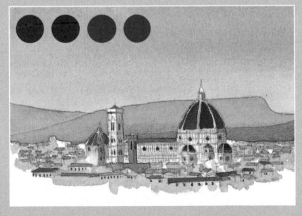

Above **Florence, Italy—complementary color harmony.**

FORMAT

Like the "rules" of color harmony, the "rules" of composition appear to come naturally to some artists, while other artists find some guidance useful. However, like all "rules" there will be times when you will need to break them.

The scene for the project on the following pages is set in Vermont in the fall, and is based on the community church in Stowe. The key components of the scene are the church, the foreground detail, the backdrop of the vivid colors of the fall, and the sky. The final composition of the picture needs to recognize the role of each of these components in communicating with the viewer, but before the picture content is discussed, we first need to consider the format of the paper.

The ancient Greeks recognized that the proportions of a rectangle have a bearing on its aesthetic effect, with the so-called "Golden Rectangle" determined to be the most pleasing. The ratios of the two sides of the Golden Rectangle are around 13 to 8 or 1.625 to 1. This is the format used for the picture of Stowe Church. Other formats can be used but this ratio has over the years been determined to be the most satisfying. A picture based on a ratio of 2 to 1 is least satisfying. As the ratio increases to 3 to 1 and beyond we once again find the format attractive. Square, oval, and circular formats are also acceptable. Be careful not to be just off square as that can also be visually disturbing.

FOCAL POINT

With the format set, a focal point needs to be found for a landscape. In this case it is Stowe Church, but it could equally well be a person, a boat on a lake, a well-positioned fence post, or a specimen tree. Avoid using the center of the picture for the focal point. In general, place the main feature one-third of the way across the sheet. The line of the horizon should also generally obey this "rule," either one-third up or one-third down the page.

To help draw the eye toward the focal point, the group of trees in the foreground has been positioned to take the eye upward, curving across the page toward the church and its spire. This curving line helps to bring some movement to an otherwise static scene. Diagonal and sloping lines in the finished scene then add a sense of movement and dynamics to the composition.

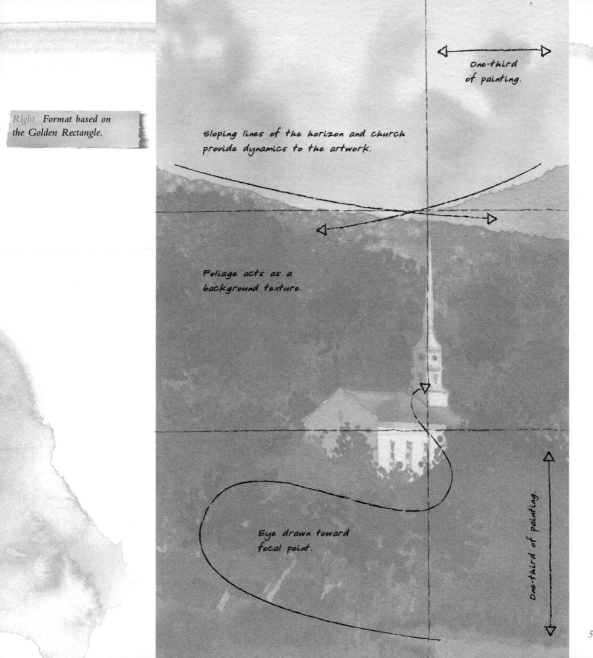

One-third of painting.

Sloping lines of the horizon and church provide dynamics to the artwork.

Foliage acts as a background texture.

Eye drawn toward focal point.

One-third of painting.

PROJECT: STOWE COMMUNITY CHURCH, VERMONT

USING COLOR AND COMPOSITION

The fall in New England provides plenty of opportunity to explore color. The reds, oranges, and yellow greens of the foliage provide a natural color harmony and the white of the spire in this location provides a useful foil and focal point for the picture. As for previous projects, you first need to create a pencil sketch. In this instance we are looking carefully at composition, and the crop marks indicating the outside edges of the painting are placed to ensure that the format fits approximately to the ratio of the Golden Rectangle. The church is then drawn with its spire approximately one-third across the page. Do not worry too much about the perspective of the church because perspective will be covered in the last project. Concentrate on creating the spire.

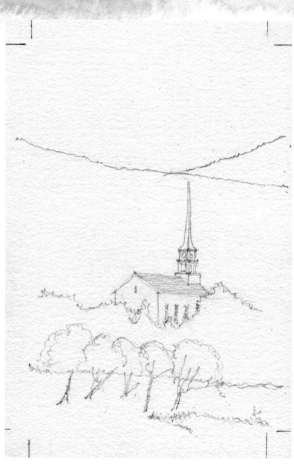

Above **Initial pencil sketch with crop marks.**

FACT SHEET

Stowe in Vermont is well known as a ski resort. Its other claim to fame is as the home of the Trapp family who in 1965 provided the inspiration for the movie *The Sound of Music* following their wartime escape from Austria. The white spire of Stowe Community Church, which is typical of other churches in New England, is well known for its marvelous setting.

Below **Sky and background mountain.**

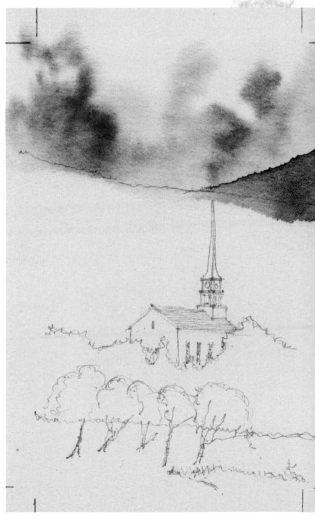

Right **Split complementary.**

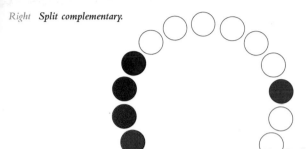

A split complementary color range based on an analogous range from red through to a yellow green with the complementary approximating to French ultramarine is used for this painting. The range is a little broad and almost moves out of a harmonious range of colors so care needs to be taken to avoid straying out of this range completely. The aim is to accentuate the brightness of the foliage color, and the sky wash of French ultramarine requires a little light red added to mute the color and make it a blue gray. The background mountain wash is applied once this is dry using a similar blue-gray color as the base, with a little aureolin and light red added to the paper, employing the wet-in-wet techniques.

STOWE COMMUNITY CHURCH, VERMONT

The next wash is taken across the middle-distance mountain and the foreground. A pale wash of aureolin and yellow ocher is initially applied. While this is still wet, additional fall colors are dropped in along the top edge of the wash using mixtures of light red with scarlet, scarlet with aureolin, yellow ocher with scarlet and aureolin with a little French ultramarine. To give the wash texture it is suggested that you once again add some salt while it is drying, scraping it away when finally dry. A further wash is added in a similar way, starting a little way down from the top edge of the mountain. This second wash should have a very broken top edge to hint at a line of foliage formed by the tops of the trees.

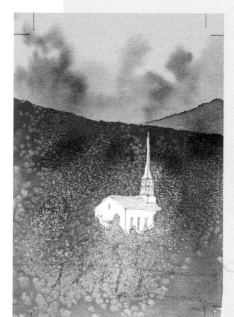

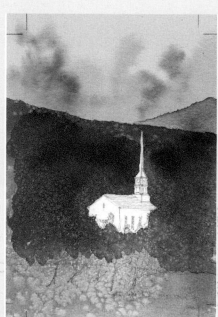

Far Left **First foliage wash.**

Left **Second foliage wash, added when the first is dry.**

The next stage is probably the most difficult. The impression of individual trees needs to be created without individually painting each tree. The washes previously prepared, along with a scarlet wash, are applied over the top of the last wash before it has completely dried. They are applied as small areas of broken color, or alternatively applied with a sponge. The aim is to create the impression of the leaves forming the tops of the various trees behind the church. In some instances, colors will blend together where the color has not fully dried, while in others the color will overlay the previous work because it has already dried.

Right **Detail added to the foliage in the middle distance.**

When you look through windows you see the deep shadow inside a building, so windows and other openings appear very dark. A near-black wash of light red and French ultramarine is used to define the openings in the building and the clock. The main windows consist of a lot of tiny panes of glass, and these should be depicted as a series of fine dots of paint within the rectangle of the window. With the darkest areas complete the general shading washes, mixed from light red and French ultramarine, can be added, giving a three-dimensional feel to the church.

Right **The details of the building.**

61

STOWE COMMUNITY CHURCH, VERMONT

Above **Starting the foreground.**

A similar process to that used for the middle distance is now required for the foreground trees and grass. However, before starting on the foreground foliage, a flat wash should be applied to the small area of water at the bottom using the same mixture as that used for the shadow areas on the building. The foreground initially has a wet-in-wet wash, with reds and yellows along the top edge and yellows with yellow greens in the area of the grass. The area of the tree trunks should be left clear so that they show through as the lighter underlying wash. As the wash dries, a few spots of color can be added to the foreground trees to hint at the leaves, and a second wash can be added to the grass area to create an impression of a line between the grass and the trees behind. If this is done when the first wash is still slightly wet, some of the colors will blend, which gives more of the feel of nature.

The final details are important although relatively simple. The fall colors of the line of trees in the foreground should be dabbed into the area of the trees to create the impression of foliage. Shadow should then be added to both the ground and the sides of the trunks. The color for the lower edges of the tree foliage can be deepened with some French ultramarine to give a sense of shadow within the foliage. Finally, fairly dry brushstrokes of yellow green and other colors are added to the foreground to give the impression of grass, along with some shadow applied where the grass joins the edge of the water.

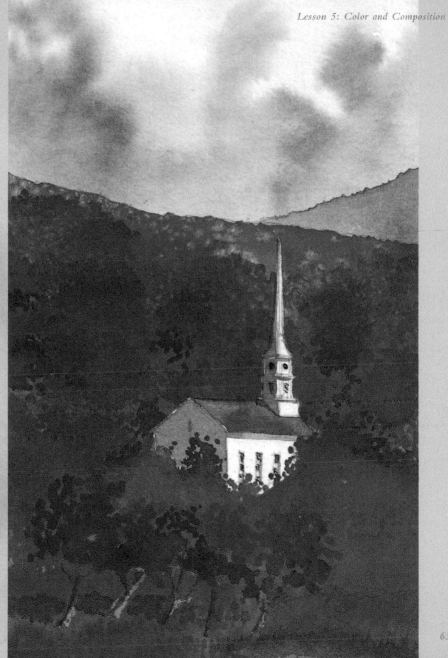

Right **The completed watercolor of the church in Stowe, now cropped back to the crop marks to match the Golden Rectangle format.**

LESSON 6: **FOLIAGE IN THE LANDSCAPE**

LIVING, VIBRANT TREES AND FOLIAGE

The appearance of trees and plants varies depending on their distance from the viewer. Trees in the far distance can be represented as simple washes, as in the example bottom-left of a sketch of Saint Brelade's Bay on the Channel Island of Jersey. For closer viewing, when the detail of the trees becomes visible, a different approach needs to be taken. The example below right shows a deciduous tree in winter. In both examples the wealth of detail seen in trees in real life has been reduced to the minimum consistent with providing an impression of a tree at the distance in question. Far more detail could be added, but that could become counterproductive, because it can produce a rigidity that detracts from the vibrancy of the natural movement of branches in the lightest of breezes.

Below **Sketch of Saint Brelade's Bay, Jersey.**

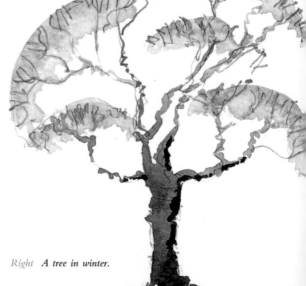

Right *A tree in winter.*

64

Few people have understood the need for creating the impression of movement and vibrancy in trees better than Vincent Van Gogh. His landscapes of southern France were built around marvelous swirling cypress trees. The examples shown on the right are very much inspired by Van Gogh. The first attempts to recreate some of the energy of the Van Gogh cypress trees blowing in a warm Mediterranean summer breeze. The second is similar, aiming to give the impression of a typical small conifer, found in gardens everywhere.

It is important to maintain the vibrancy of life in all shrubs and flowering plants. In the example below, which was prepared as a demonstration sketch in an adult education class, the aim was to create an impression of the exuberance of a domestic garden in summer.

Variegated wash used to evoke the impression of the detail to be found in the real tree.

Swirling lines aim to evoke sense of life and movement.

Above **Cypress tree.**

Watercolor extended and fragmented to give the impression of life and vitality.

Shading helps to indicate shape and volume.

Above **Conifer tree.**

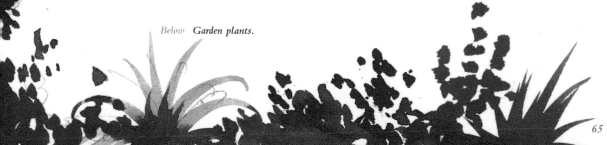

Below **Garden plants.**

TREES THROUGH THE SEASONS

Understanding the structures and shapes of trees is crucial to painting trees in the foreground. The basic structure of deciduous trees is the same but the shape varies according to the species. A mature oak has been used for the examples on this page. Oaks have a squat appearance and the crown is very open in summer, allowing a lot of light through to any vegetation below.

Variegated washes have been used for the summer tree, with the impression of leaves given by tiny spots of paint, allowed to "escape" from the body of the wash. Shading on the undersides of the leaf formations provides three-dimensional qualities and this would be enhanced by adding shadow on the ground.

In fall the leaves tend to be thin, and vary in color from yellow green, through yellow to red. Variegated washes have been applied to give an indication of the sparse leaves on the many twigs at the ends of the branches. A tree in spring is similar, except that the leaves are a bright yellowish green.

Winter reveals the skeleton of the tree. The main trunk and the branches steadily reduce in size the higher they grow. At the very tips of the branches are many fine twigs, which have been represented by a light arching wash. Shadow has been applied to the main trunk to give it solidity.

Above **Oak in summer.**

Above **Oak in fall.**

Above **Oak in winter.**

PALM TREES

The iconic palm tree is synonymous with the idea of warm and relaxing vacations. The key to producing palm trees in watercolor is an understanding of their pattern of growth. Each year a new group of leaves grow leaving others to wither and die. We see the effects of this in the horizontal bands around the trunk and the mixture of colors in the palm leaves. The older leaves often point straight down before they finally drop away.

SHAPES IN THE LANDSCAPE

Some of the most interesting landscapes occur where different types of tree and planting are brought together in one location. This is particularly noticeable around Lake Garda in Italy. The lake is surrounded by gardens and by towns, all of which are populated with many trees. The slopes of the mountains that abut the lake are covered in a mixture of rounded deciduous trees, punctuated by tall and majestic cypress trees. The whole creates a vibrant and gardenlike landscape.

Below **Lake Garda, Italy.**

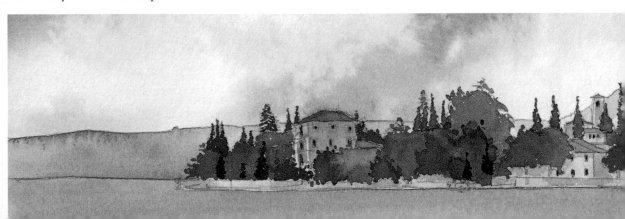

PROJECT: HAWAIIAN BEACH PALMS
PAINTING TREES AND FOLIAGE

This project is based on the view across to Molokini from Makena Bay on the Hawaiian island of Maui. Care needs to be taken in the initial sketch to ensure that the horizon is level and straight.

The sky is probably the most difficult part of this watercolor and it may not be possible to reproduce it exactly. An initial variegated wash needs to be applied using various colors as indicated. While this is drying, the edge of a folded piece of absorbent tissue paper is used to lift out straight lines within the wash to give an indication of the rays formed by a sun hidden behind the clouds. While the underlying wash continues to dry, additional areas of light red mixed with French ultramarine and a little permanent rose are added to form the darker clouds. Where the edges of these clouds lack softness a little plain water can be touched in. It is this added water that then produces the "flare" of light in the dark clouds near the sun.

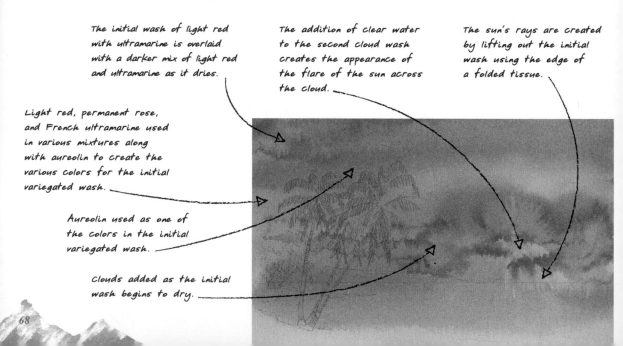

The initial wash of light red with ultramarine is overlaid with a darker mix of light red and ultramarine as it dries.

The addition of clear water to the second cloud wash creates the appearance of the flare of the sun across the cloud.

The sun's rays are created by lifting out the initial wash using the edge of a folded tissue.

Light red, permanent rose, and French ultramarine used in various mixtures along with aureolin to create the various colors for the initial variegated wash.

Aureolin used as one of the colors in the initial variegated wash.

Clouds added as the initial wash begins to dry.

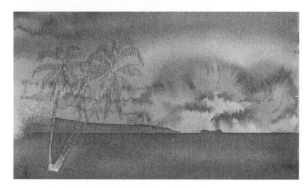

Above **The initial wash to the sea and islands.**

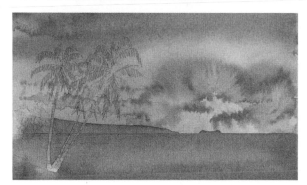

Above **The second wash to the sea and islands.**

FACT SHEET
Maui is the second largest of the Hawaiian islands and is named after the demigod who is supposed to have given fire to humans. It is formed from the remains of two giant volcanoes: one in the northwest and one in the southeast. Makena Bay is in the middle of the island on the west side.

Three washes are required to add the sea and distant land shapes. An initial variegated wash is applied across the entire area, using light red mixed with French ultramarine in the distance and aureolin in the foreground. Two similar washes are then applied, and each allowed to dry fully. The first of these two washes should be taken across the small island while omitting the larger land mass, while the final wash is simply taken across the sea. In each case the wash needs to be applied in the areas between the palm trunks while leaving the trunks free of color. Adding washes in this way exploits the transparent qualities of the medium.

Right **The final wash to the sea.**

HAWAIIAN BEACH PALMS

The next washes are used to insert the promontory in the middle distance and the deciduous trees and planting on that promontory. The trees need to be kept loose and fluid, with spots of paint used to indicate the leaves. The foliage is in shadow and the color is a very muted green, produced using varying mixtures of light red, French ultramarine, and aureolin. The sandy shoreline has rocks and these are added next using variegated washes based on various mixtures of light red and French ultramarine. With the previous washes now dry, the palm trees are added

Below **The middle distance.**

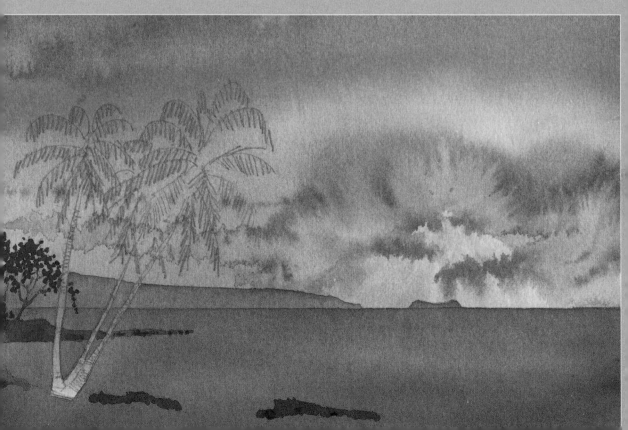

along with the small area of foliage to the left. The leaves of the palms use a range of muted greens while the trunks are built up from a range of muted yellows based on yellow ocher, aureolin, light red, and French ultramarine. The very muted colors create the impression of trees in shadow. The palms now become a key component of the composition. Finally, the shadows of the palms and rocks are added to the beach, and a sharp knife is used to scratch the surface of the paper to produce the appearance of ripples on the sea.

Below **The finished watercolor of the Hawaiian beach palms.**

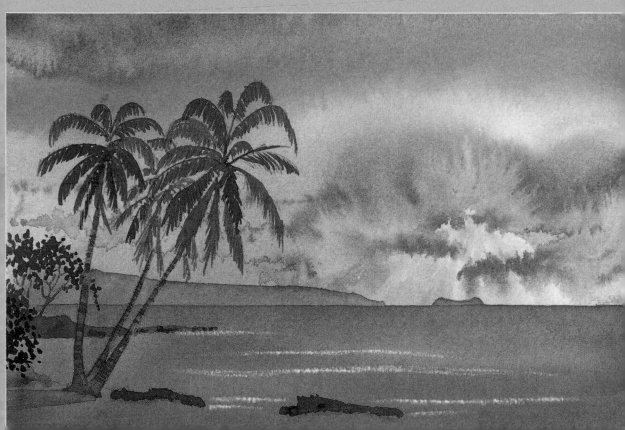

LESSON 7: PERSPECTIVE AND SHADOW

KEY CONCEPTS OF PERSPECTIVE

Since the Renaissance, artists have used the rules of perspective to help create the illusion of three dimensions. A basic understanding of perspective is particularly useful when depicting manmade objects such as buildings and bridges. Such structures often form part of our landscape and act as the focal point for scenes. The easiest way of visualizing perspective is by imagining a large, clear plane through which we can view and trace the scene beyond. This is known as the picture plane.

Picture Plane

Viewpoint

Horizon Line

The location of the horizon is important in setting up a perspective drawing. When you are standing on a beach looking out to sea the horizon is obvious. Within a normal landscape or townscape the horizon is often obscured, but the concept of the horizon is still of use in constructing the perspective. The horizon helps you to set people accurately within your landscapes. Assuming others around you are all about the same height and that they are standing on ground that is at the same level, then all their heads will be on the horizon, no matter how far away they are standing. In practice the horizon is your eye level projected into the furthest distance, and the eyes of all other people of the same height and standing at the same ground level will also be on our horizon. An understanding of this can be useful in setting up buildings: people have to fit through doors in buildings, so door heads will always be just above your horizon for all buildings at your ground level.

VANISHING POINTS

If you imagine yourself standing on a long, straight highway, then you will be conscious of the next key concept, vanishing points. The highway and any roadside furniture such as telegraph poles recess into the distance toward a single point, known as the vanishing point.

This form of perspective, where all the elements converge on a single point, is known as one-point perspective. Looking straight at the front of a building like the English pub in the watercolor on the right, you also see the building in one-point perspective. In this example the ground slopes gently, so the hidden horizon line goes through the head of the door rather than two-thirds of the way up. The key lines of the ridge, gutters, and junction with the ground of the two protruding wings and of the protruding bricks on the chimney all recess to a single vanishing point on the hidden horizon. However, the key lines on the front face of the building, which is perpendicular to our view, are parallel to each other.

Horizon Line

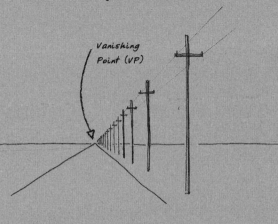

Poles appear closer together as they approach the vanishing point.

Vanishing Point (VP)

Below **William Cobbett Public House, Farnham, England:** *an example of one-point perspective.*

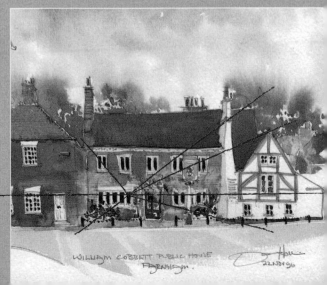

WILLIAM COBBETT PUBLIC HOUSE
FARNHAM.
22 NOV 96

TWO-POINT PERSPECTIVE

We frequently approach buildings and other structures at an angle. In perspective, this creates two vanishing points, with the key lines of each of the main faces going to different vanishing points. Both the vanishing points, however, sit on the horizon line. The sketch of the Pont du Gard, the Roman aqueduct near Nîmes in southern France, shown below, illustrates two-point perspective. The principal lines of the aqueduct run to the vanishing point on the left. The horizon line is near the base of the aqueduct as the scene is being viewed from the rocks beside the riverbed that runs under the aqueduct. The less obvious spring points of the arches and the courses of stone, however, are in the second dimension, with the lines of these elements receding to the vanishing point on the right. The lines of the bottom edge of the shadows under the arches are thrown at an angle by the sun and do not recess to either of the vanishing points. As can be seen in this example, the two vanishing points are not necessarily equidistant from the center of the picture.

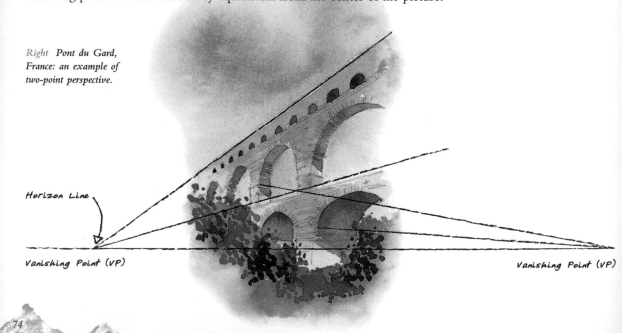

Right **Pont du Gard, France: an example of two-point perspective.**

Horizon Line

Vanishing Point (VP)

Vanishing Point (VP)

THREE-POINT PERSPECTIVE

Our visual world comprises three dimensions. When you are looking at a low structure you tend to see the vertical lines forming the third dimension as parallel, because the vanishing point is a long way away. However, if you look up at a tall structure you begin to see that the lines converge in the third dimension. In the watercolor of the tower of the Duomo in Florence, Italy, on the right, the vanishing points for the walls of the cathedral have been omitted for clarity and the principal vertical lines have been identified. Compared with the overall size of the picture the vanishing point is still some distance away but the lines are, nevertheless, converging. On a tall structure such as this, drawing the lines parallel would give a distorted view.

As an exercise it is worth checking a number of photographs of buildings to determine the vanishing points and horizon line as this can help you develop a better understanding of perspective.

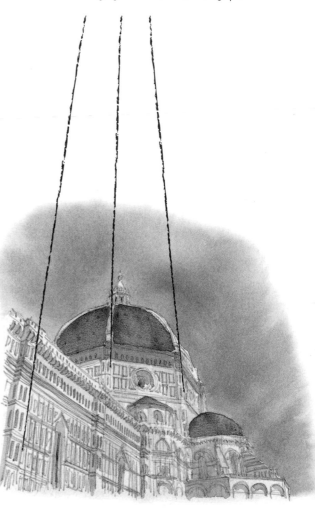

Lines converging to distant vanishing point.

Right **Duomo in Florence, Italy: an example of three-point perspective.**

MULTIPLE VANISHING POINTS

The previous examples were all applicable to a single structure. Where there are multiple structures that are at an angle to each other, there will be multiple vanishing points, although the vanishing points of the horizontal lines will all still sit on your horizon. For a road, or for a row of posts going downhill as in the example below, the vanishing point will, however, no longer remain on the horizon. The posts recess in the same way as for the example of telegraph poles on page 73, but because the road and footpath are sloping away from the viewpoint the vanishing point is below the horizon. Although it may look complex, such a scene can easily be created if the vanishing points for each individual house or group of houses are held in the mind as the sketch is prepared. Minor inaccuracies will not be noticed providing the viewer sees the principal lines converging to appropriate points.

FACT SHEET
The rules of perspective were first developed by two architects from Florence: Leon Battista Alberti (1404–1472) and Filippo Brunelleschi (1377–1446). Brunelleschi is probably more famous for his work as the architect of the dome of the cathedral featured on the previous page. A fresco of the Trinity by Masaccio in Santa Maria Novella, Florence, is one of the earliest pieces of art to use the newly found perspective rules.

Below **Gold Hill, Shaftesbury, England: an example of multiple vanishing points.**

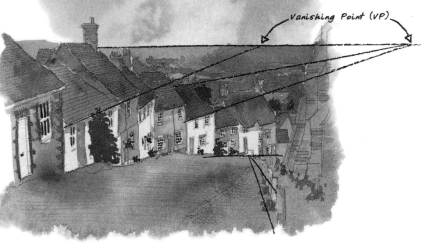

Vanishing Point (VP)

APPROXIMATE MEASURING IN PERSPECTIVE

The two illustrations below demonstrate how it is possible to position repeating elements such as posts or windows in perspective correctly, using a diagonal construction line that runs from the bottom of one element through the middle of the next to indicate the location of the third. This can be useful in creating a very approximate framework into which detail can be added.

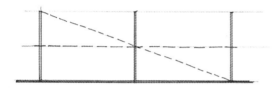

When posts are equidistant and the same height, a diagonal line from the bottom of one through the middle of the second will mark the top of the third.

Set the vanishing point lines of the first two posts. Identify the midpoint of the second post. Draw a diagonal to locate the position of the third post.

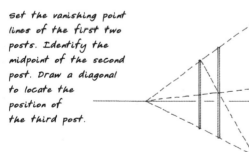

Creating a diagonal from the bottom of one post through the middle of the next allows us to locate the next post in perspective.

ADDING SHADOW

Shadow brings three dimensions to life, giving a feeling of solidity. In this example of the Château Chillon on Lake Geneva, shadow has been added to the distant mountains to indicate the faceting of the surface, and also to the château. The walls facing away from the sun are completely covered in shadow, which has also been applied under the eaves. In addition, a small area of cast shadow is shown in front of the shaded walls and behind the chimneys on the roofs. Although the sky is often overcast and little shadow can be seen, it pays to use a little artistic license and add shadow to help the viewer appreciate the three-dimensional nature of the building or landscape elements.

Below **Château Chillon, Switzerland, made famous by Lord Byron.**

PROJECT: TREASURY BUILDINGS, PETRA

CREATING PERSPECTIVE AND SHADOW

The key to this project lies in the initial setting of the perspective. The subsequent washes are relatively easy to execute. The famous Treasury building is an intrinsic part of the landscape of Petra, Jordan, having been carved from the solid rock many centuries ago. Your eye level is approximately in line with the bases of the main columns resting on the top of the steps. This sets the horizon line. Most of the elements of the façade recede to a vanishing point well to your left as we are only just away from a position where you would be looking straight at the building. If you could move a short distance away and be perpendicular to the face of the building, it would become a one-point perspective requiring all the lines of the front of the building to be parallel.

Returning to the actual viewpoint, it is important to notice that the principal lines of the return elements which go into the rock face all go to a vanishing point on the horizon on your right, while the vertical lines recede to a vanishing point some distance above the picture. Only one of the vanishing points lies even close to the picture, so it is necessary to use your judgment to create lines that, if extended, would go to one of the three vanishing points.

Above **The initial pencil sketch.**

Below **The vanishing points.**

FACT SHEET

Petra is in present-day Jordan. It is an ancient city dating back to the time of Christ and is in the area in which, according to tradition, Moses struck a rock and water gushed forth. In 106 C.E. it came under the controlling power of the Romans and continued to flourish as a trading city. However, changes to the trade routes and earthquakes eventually led to its decline and it became unoccupied and was lost to the western world until its rediscovery by the Swiss explorer Johann Ludwig Burckhardt in 1812. The "Treasury," which is actually a tomb, is probably the best known of the visitor sites.

Vanishing Point (VP)

People going up steps are above our ground level and their heads are, therefore, above the horizon line.

VP

Horizon Line

VP

TREASURY BUILDINGS, PETRA

After the drawing is complete, an initial wet-in-wet wash should be applied across the entire area of the picture, dropping the color into the wetted surface of the paper. The color is based on various mixtures of permanent rose with light red and touches of aureolin. To create the vignette style, where the picture fades into a white background, the amount of color should be decreased toward each edge with possible help from a dampened tissue or sponge to mop the color out of the edges of the picture.

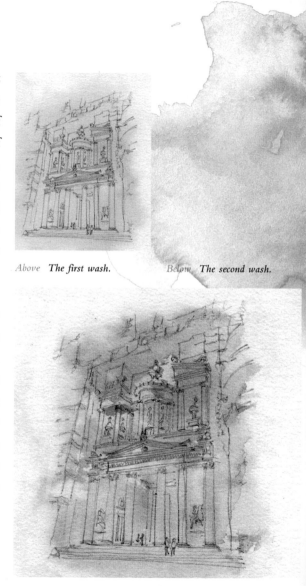

Above **The first wash.**　　　*Below* **The second wash.**

When the first wash is dry, a film of water should be reapplied across the paper and a second wet-in-wet wash applied using similar colors to the first wash, as well as a muted green color made from French ultramarine with yellow ocher and aureolin in various mixes. By applying the second wash, greater diversity of color change can be achieved to give a more "rocklike" appearance. To help this process further some of the color should be "lifted out" with a tissue to produce the very light areas.

Finally, shadow needs to be added. All the shadow areas should be washed with a mixture of French ultramarine and light red. The quantity of water will need to be varied to produce the deep shadows of the doorways and the lighter shadows of the general areas.

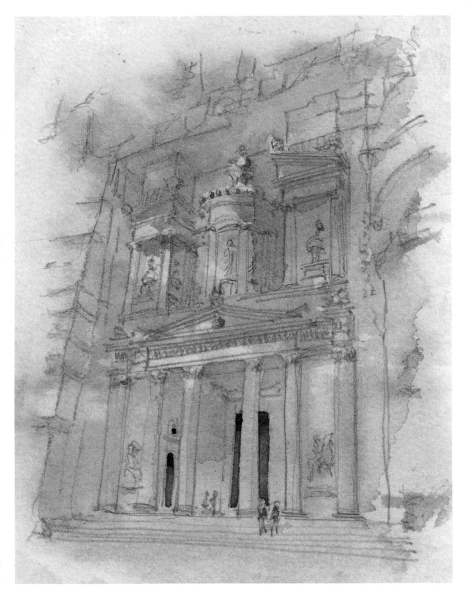

Right **The finished watercolor of the Treasury at Petra.**

A SKETCHING TRIP TO THE WEST OF IRELAND

SKETCHING EQUIPMENT

Artists over the years have found watercolor very useful for travel and outdoor sketching. The necessary equipment for watercolor is limited and it is a fairly clean medium to use. Some retailers sell watercolor boxes specially made for sketching. I use an old "Frazer Price" box, which includes water pots, a water container, palette space, colors, and brushes all within one compact shape. Although I believe the Frazer Price boxes are no longer made, compact boxes specially designed for sketching are made by other manufacturers. Alternatively, you can put together a relatively small bag to carry all the separate components.

Alongside the box there is a need for a chair, or if you prefer to stand, an easel. These days there are many lightweight examples made specifically for artists. In my own case I use a folding chair that is light enough and small enough to fit into a suitcase for travel by air. Ideally the chair should also be fairly low to allow materials to be placed easily on the ground when not in use.

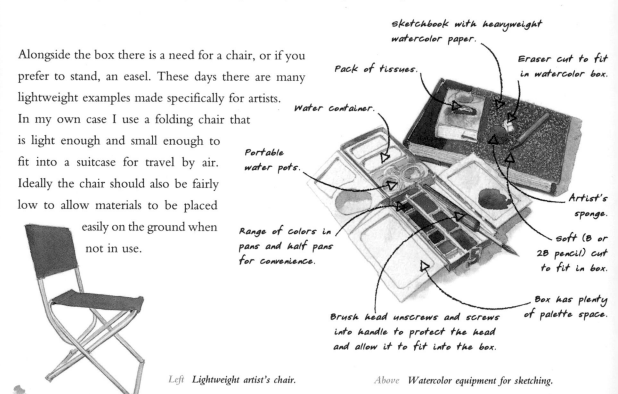

Sketchbook with heavyweight watercolor paper.

Pack of tissues.

Eraser cut to fit in watercolor box.

Water container.

Portable water pots.

Range of colors in pans and half pans for convenience.

Artist's sponge.

Soft (B or 2B pencil) cut to fit in box.

Box has plenty of palette space.

Brush head unscrews and screws into handle to protect the head and allow it to fit into the box.

Left Lightweight artist's chair.

Above Watercolor equipment for sketching.

THE WEST COAST OF IRELAND

The visitor to the west of Ireland is spoiled for choice. To the extreme southwest of Ireland are the counties of Cork and Kerry. This is one of the most popular areas, with many visitors touring the famous Ring of Kerry. Further north you have Limerick and County Clare sitting on either side of the Shannon River, while still further north you have Galway, Mayo, Sligo, and Donegal. This sketching trip is centered on the northern part of County Clare and the southernmost part of Galway. The area is well known for the limestone plateau called the Burren. The landscape is green with scattered stone outcrops and ruins of castles and churches, while along the coast you find a mixture of cliffs and fishing villages, all of which provide subject material for the itinerant artist.

The sketching trip starts with the Cliffs of Moher before heading northward to the small port of Doolin from where the ferries leave for the Aran Islands. From Doolin we travel north past the ancient remains of Leamaneagh Castle and Carran Church and on toward the lovely fishing village of Kinvarra in Galway.

Heading back south again we call at Thoor Ballylee, the home of the poet Yeats, before looking in at the ruined monastery of Kilmacduagh. The trip finishes back in County Clare at the secluded Lough Bunny, which despite its beauty, appears to be missed by most visitors to the area. The weather can be unpredictable so ensure you take some wet weather clothing!

Right **Map to show route of the sketching trip.**

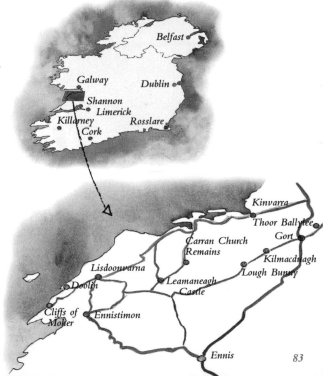

83

O'BRIEN'S TOWER AND THE CLIFFS OF MOHER

Above O'Brien's Tower on the Cliffs of Moher.

Toward the northern end of the Cliffs of Moher stands O'Brien's Tower, a tourists' viewing point built in the 19th century. The cliffs are formed of layers of shale and sandstone, and create clear lines of deep shadow. For the sketch, the sky wash was completed first, using a wet-in-wet wash to depict the cumulus clouds. A simple flat wash of French ultramarine with a touch of light red was then applied to create the area of the sea, giving it the characteristic deep blue color seen on a bright and sunny day. The cliffs in the middle ground were painted with another wet-in-wet wash, which allowed the sandstone colors of the cliffs to merge with the green of the grass just as they do in real life. Before the wash was applied a candle was run over the area of the rocks on the cliff face to ensure that some areas remained white. Once this wash was dry a few added touches were applied to the tower and the foreground.

The initial wet-in-wet sky wash is allowed to go through the horizon to avoid a white line at the junction with the sea.

A simple flat wash is then added across the area of the sea.

A candle ensures highlights on the cliffs before a variegated wet-in-wet wash is taken across land areas.

The tower and foreground details are added with dry brushstrokes to create the impression of grass.

DOONAGORE CASTLE

Doonagore Castle holds an imposing position above the village of Doolin. It was constructed from the stone of the region in the early 16th century and was occupied by Boetius Clancy, who was High Sheriff of the County of Clare late in that century. The castle is privately owned but still provides artists with an ideal subject as the view from the road sets the castle against the backdrop of the distant Aran Islands.

The sketch uses similar techniques to those that were used for the Cliffs of Moher, although in this picture the sky was first completed as a flat wash before the clouds were defined using the edge of a folded absorbent tissue to "lift out" some of the French ultramarine color and create the areas of white. The islands and sea were both flat washes, while the foreground and castle areas were created from wet-in-wet washes. In the case of the castle the first wash was overlaid by two further washes in order to build up the blocks of color and give the impression of the marks and texture of the stonework and of the shadows cast. The greens of the foreground were all muted greens made using various mixes, comprising French ultramarine, aureolin, light red, and yellow ocher, while the mixes for the castle were based on yellow ocher with small amounts of light red and French ultramarine. The shadows and darks in the windows were formed of French ultramarine and light red.

Below **Doonagore Castle.**

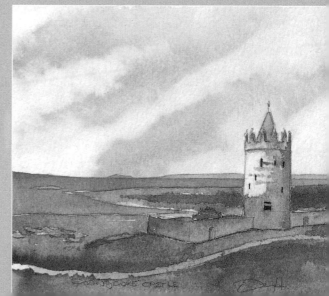

FISHERSTREET, DOOLIN

Fisherstreet is one of a group of small communities that are collectively known as Doolin. The whole area has become a well-trodden path for tourists in recent years as Doolin is increasingly identified as a major cultural center for traditional Irish music. As a result of the growth in popularity of Irish music around the world, Fisherstreet and Doolin, despite their small size, are now firmly on the international map.

The buildings are like many in that part of Ireland—small and simple with brightly painted exteriors. The sketch depicts the view from the road above Fisherstreet looking down on the small group of village shops. In the background there is a pattern of fields and isolated dwellings, along with some ruined remains so typical of the area. The sketch concentrates on the detail of the foreground, the shops. A medium to soft 2B pencil has been used to define the architectural details and care has been taken to ensure the accuracy of the perspective. The deep shadow in the windows helps draw the eye to the focal point of the sketch, while the more general shadows cast by the buildings help define the three-dimensional forms. The foliage in the foreground has been created using sponge and left very simple to avoid detracting from the detail of the street scene.

Above and below **The key to this sketch is the detail built into the focal point: the stores in Fisherstreet, Doolin.**

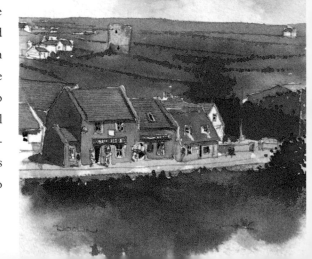

THE ARAN ISLANDS FERRY AT THE PIER IN DOOLIN

Fisherstreet extends down to a pier from which the ferries head out to the three Aran Islands: Inisheer, Inishmaan, and Inishmore. The closest island and also the smallest is Inisheer, on which stand the ruins of the 15th-century O'Brien's Castle built by the family who owned the islands until the late 16th century. Inishmann, the middle island in both size and distance from the mainland, is famous for its plants, while Inishmore is the largest and most distant of the three islands and attracts visitors to its ancient forts and churches.

Capturing a ferry in a sketch is difficult. Patience is required in waiting for the ferry's arrival and then, in no time the ferry is on the move again. The ferry is the focal point in the sketch and, therefore, requires the strongest colors and contrasts. The cliffs of Moher in the background have been grayed out to give the impression of distance, while the rocks in the foreground have been kept simple to ensure the eye is drawn toward the ferry and the line of passengers. For speed the sea was painted as flat wash, but once dry a knife was used to scratch away the watercolor at the edges of the sea in order to create the impression of small waves breaking against the shoreline and pier, and to suggest that the ferry was just completing its final movement toward the harbor pier.

Above **The ferry at Doolin at mid-tide.**

LEAMANEAGH CASTLE

Heading inland from Doolin through Kileenora you reach the reputed haunted remains of Leamaneagh Castle, which also goes under the name of Lemaneh Castle. The castle is in two parts—a later, substantial house, added to an earlier tower. The house was constructed by Conor O'Brien in the mid-17th century. While Conor O'Brien died fighting the Cromwellians, his wife appears to have avoided confiscation of the property and estate by subsequently marrying a Cromwellian soldier.

Although the remains of the castle are on private land they can be clearly seen from a number of vantage points along the roadsides. Key to this sketch is ensuring the right balance of composition between the foreground trees and the castle remains. Unlike buildings with roofs, the interior is fairly bright, so apart from a couple of the windows, you no longer see deep shadow as you look through the slit windows in the castle walls. To ensure that there were enough deep tones near the focal point for the sketch a dark green was used for the tree immediately in front of the castle. The foliage of the foreground trees was generally kept loose and free to give life to what would otherwise be a fairly static picture. The early tower from which the castle was eventually extended can be seen at the right-hand side of the sketch.

Above **Leamaneagh Castle.**

CARRAN CHURCH

Heading north from Leamaneagh Castle toward the famous rocks on the plateau of the Burren you pass the remains of yet another ancient building, Carran Church. The church was built in about 1500, and although the structure is in ruins the burial ground is, I believe, still in use. The church sits back from the road, standing on the plateau surrounded by low stone walls protecting the burial ground.

The sketch aims to display something of the isolation of the church, sitting within the grassland with small outcrops of rock and a lonely tree to the north. The horizon is placed about one-third of the way up the sketch to give predominance to the angry sky. The wash for this was quickly achieved using wet-in-wet methods with varying mixtures of French ultramarine and light red dropped into a wetted surface. The grass area consists of various mixtures of French ultramarine with aureolin, as well as a little yellow ocher, while various mixtures of French ultramarine, yellow ocher, and light red were used to create the detail on the stone walls. The starkness of the shading on the church walls helps to add to the sense of isolation on the windswept plateau.

Above **Carran Church.**

KINVARRA

From Carran Church we move on to Kinvarra, a popular fishing village in its own bay, which itself leads out to the much larger Galway Bay. The quayside sits at the center of the village, with shops, pubs, and restaurants all located close to the harbor. Although the village sits on a fairly busy road, once you are down by the quay it takes on a tranquil feel, with locals and visitors alike taking the benefit of the picturesque views. Just across the bay lies Dunguaire Castle which was built in 1520 and is now open in the summer season for visitors.

With the tide out it was possible to sit on the slipway and look across to the boats leaning against the quayside. The colors of the water and the mudflats appeared to merge as I looked toward the buildings and quayside. As a result I decided to change my technique for this sketch. An initial pencil outline was prepared and then a single wet-in-wet wash was applied, allowing the colors of one area to merge with those of other areas into one, single abstract area of color. A folded absorbent tissue was used to take out the highlights on the boats and quayside, and as the wash began to dry a few detail elements were added, such as the shadow under the eaves on the buildings. Once the wash was finally dry an Indian ink pen was used to define the forms of boats, buildings, trees, and quayside.

Above **The author sketching.**

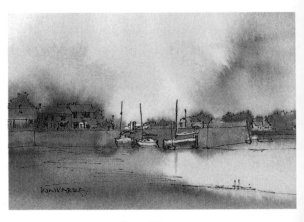

Above **Kinvarra.**

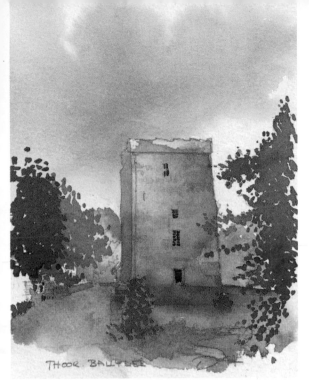

Above **Thoor Ballylee.**

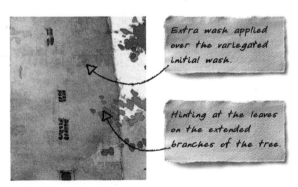

Extra wash applied over the variegated initial wash.

Hinting at the leaves on the extended branches of the tree.

Above **Thoor Ballylee—
detail of stonework.**

THOOR BALLYLEE

Southeast of Kinvarra you find Thoor Ballylee, the summer home between 1919 and 1929 of W. B. Yeats.

*I declare this tower is my symbol; I declare
This winding, gyring, spring treadmill of a stair is my
ancestral stair.*

From "Blood and Moon"

W. B. YEATS

The Irish word for tower is *thoor*, and Yeats used it to describe his Galway home. The tower sits beside a stream and among the trees. A similar approach has been used as for the other sketches. A simple French ultramarine-based sky was followed by a light-green wash for the far trees using French ultramarine and aureolin. With the tower as the focal point it was important to ensure that there was texture to the stonework, so an initial variegated wash of mixtures of French ultramarine with aureolin and yellow ocher as well as yellow ocher on its own, was applied initially. While that was drying, specific stones were highlighted using a light-gray wash of French ultramarine and light red. Once again, using dots of color to indicate extended branches and leaves ensured that the trees and foliage had as much life as possible.

KILMACDUAGH

Just in Galway, on the border with County Clare and just off the road from Gort to Corofin, lie the remains of the monastery founded by Saint Colman the son of Daugh, in the early 7th century. The buildings can be seen from some distance away, thanks to the high leaning tower, which was built some 500 years after the monastery was first founded. The tower is about 100 ft (30 m) high and is also about 2 ft (0.6 m) out of true.

With time running short and still one more place to visit, a quick line and wash sketch was once again prepared, using candle wax on the tower to hint at the stones glistening in the fading light. With line and wash it is important that the underlying color does not match the line exactly or a childlike "painting by numbers" appearance can result. The loose and varied wash provides abstract background, hinting at the color, while the line defines the form. You can choose to place the line either before or after the color, although it is obviously essential that the waterproof qualities of the ink are tested if the line is to be placed before the wash. The Indian ink drawing pens used by draftsmen provide the best option.

Below **Kilmacduagh.**

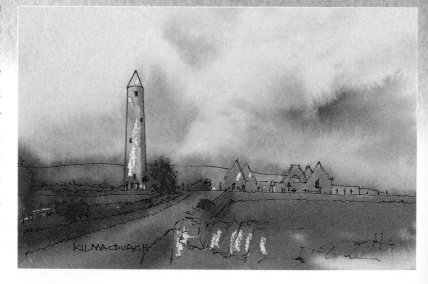

LOUGH BUNNY

Lough Bunny can be found just south of Kilmacduagh on the Corofin Road. It is a beautiful lake with an abundance of fish species, which attracts the local fishermen.

The sun was getting lower in the sky by the time we reached Lough Bunny, but it was hidden behind a thin layer of clouds. This produced a glistening on the distant parts of the lake, with the reeds in the foreground in shadow contrasting against the lighter lake. In the immediate foreground were small rocks and silt protruding just above the surface of the shallow edges of the lake. The distant hills and foliage were all a blue gray, adding to the feeling of evening stillness and peace. The aim was to capture something of that moment in the sketch.

Below **Lough Bunny.**

With Lough Bunny, the sketching trip and book must draw to a close, but hopefully you will be inspired to try such a trip and enjoy the experience of creating watercolor sketches on location. Once the basic watercolor techniques have been mastered it can be a very relaxing and enjoyable experience. As with all new skills, at the start it may seem very hard, but time, persistence, and patience will bring the necessary rewards.

GLOSSARY

ACID FREE
Papers used for watercolor should be acid free and close to 7pH if degradation of the watercolor is to be avoided with time. All of the major recognized brands meet these criteria.

DECKLE EDGE
The uneven edge of handmade watercolor papers.

DRY BRUSH
The application of a fairly dry mix of watercolor, generally over the top of a previously dried wash, to give the impression of textures, such as that of grass.

FLAT WASH
The act of applying an evenly colored area of watercolor to paper.

GOUACHE AND POSTER COLOR
Opaque watercolors; they are not suitable for the range of techniques described in this book.

GRADATED WASH
The act of applying an area of color to watercolor paper where the level of saturation of the color varies to give the impression of going from a darker to a lighter area of color.

GUM ARABIC
Used in the production of watercolor, and also as an additive to increase gloss.

HOT PRESSED (HP)
A smooth-surfaced watercolor paper not recommended for general watercolor work, but ideal for producing specialist detail work such as architectural illustrations.

HUE
The quality of a color that allows it to be described as red, or blue, and so on.

LIFTING OUT
Using an absorbent sponge or tissue to remove color from a wet wash so that a white area is left behind.

NOT PRESSED (NOT)
A semi-rough surface to watercolor paper, which is ideal for most watercolor work.

OPAQUE COLOR
A color, such as scarlet, that tends to reflect most of the light, masking any underlying color.

OX GALL
A wetting agent, used as an additive, that increases the ease of flow of watercolor.

PAN AND HALF–PAN COLORS
Pans and half pans are small blocks of solid watercolor supplied in plastic containers. The color is less fluid and less easy to pick up than tube color, but can be more convenient.

PAPER WEIGHT
Watercolor paper comes in a range of paper thicknesses, which are measured by weight. The lightest is about 75 lb or 150 gsm (grams per square meter) and the heaviest is about 300 lb or 600 gsm. (Where the weight is stated in pounds it refers to the weight of a ream of paper.)

PERSPECTIVE DRAWING
A way of recreating three-dimensional space on a two-dimensional surface.

RESISTS
Materials such as candle wax and masking fluid that resist the watercolor as it is applied, thus leaving untouched areas.

ROUGH
The most textured surface for watercolor paper. It is not recommended for beginners.

SABLE
A natural hair used in the best watercolor brushes. Kolinsky sable is considered to be the best sable.

SATURATION
As you add more watercolor to a pool of water you increase the color saturation.

STRETCHING
Preparing paper by taping it to a board while wet and then allowing to dry and stretch before use.

SYNTHETIC HAIR
Brushes with synthetic hair are being used increasingly by artists as their quality improves. The cost is considerably less than that of sable.

TINTING
Adding increasing amounts of water to watercolor decreases the saturation of the color. This is called tinting.

TONAL VALUE
Black is the darkest tone and white the lightest tone. The range of possible grays between black and white provides the full range of tonal values. The tonal value of a particular color depends on the darkness or lightness of that color if copied in a grayscale copier.

TRANSPARENT COLOR
Some colors, such as permanent rose, tend to allow light to pass through them when used as a wash. These transparent washes allow the color of any underlying washes to be seen through them.

TUBE COLORS
Watercolor supplied in tubes; it is generally more free-flowing than pan color. The color is initially squeezed onto the palette and then picked up with a brush to be mixed into washes.

VARIEGATED WASH
The act of applying color that varies and blends across a chosen area.

VIGNETTE
Producing a watercolor that blends into the surrounding area of white paper so that when mounted and framed you see the white surround to the watercolor.

WET-IN-WET WASH
The act of applying additional colored washes before the previous wash has dried.

WET OVER DRY
The act of applying an additional colored wash over an existing colored wash. This requires the use of transparent colors.

INDEX

ACKNOWLEDGMENTS

M. Noiroe-Nerin for permission to
include the watercolor sketch of the
dovecote at Château Saint-Gervais
on page 37.

Dover images: 6
© Norwich Castle Museum and
Art Gallery/Bridgeman images: 7